AMERICAN ART

OF THE TWENTIETH CENTURY

TREASURES OF THE
WHITNEY MUSEUM OF AMERICAN ART

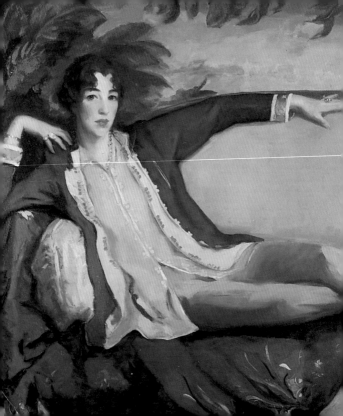

AMERICAN ART

OF THE TWENTIETH CENTURY

TREASURES OF THE
WHITNEY MUSEUM OF AMERICAN ART

FOREWORD BY David A. Ross
INTRODUCTION BY Adam D. Weinberg

CHAPTER INTRODUCTIONS BY
Adam D. Weinberg and Beth Venn

A TINY FOLIO™
WHITNEY MUSEUM OF AMERICAN ART, NEW YORK
ABBEVILLE PRESS PUBLISHERS
NEW YORK LONDON PARIS

ABBEVILLE PRESS
EDITOR: Jeffrey Golick
COVER DESIGNER: Celia Fuller
DESIGNER: Kevin Callahan
PRODUCTION MANAGER: Stacy Rockwood

WHITNEY MUSEUM OF AMERICAN ART
PUBLICATIONS DEPARTMENT: Mary E. DelMonico, Nerissa C. Dominguez,
 Brian Hodge, Sarah Newman, Ann Sass, Sheila Schwartz
CURATORIAL STAFF: Adam D. Weinberg, Beth Venn, Naomi Urabe
RIGHTS AND REPRODUCTIONS: Anita Duquette
RESEARCH: Kate Rubin

Front cover: Jasper Johns, *Three Flags*, 1958. See page 179.
Back cover: Edward Hopper, *Early Sunday Morning*, 1930. See page 81.
Spine: Claes Oldenberg, *Soft Toilet*, 1966. See page 183.
Frontispiece: Detail of Robert Henri, *Gertrude Vanderbilt Whitney*, 1916. Oil on
 canvas, 50 x 72 in. (127 x 182.9 cm).
Page 8: Marcel Breuer, Whitney Museum of American Art, 1966, New York.
Page 14: Detail of John Sloan, *The Picnic Grounds*, 1906-7. See page 21.
Page 36: Detail of Max Weber, *Chinese Restaurant*, 1915. See page 40.
Page 74: Detail of Reginald Marsh, *Twenty Cent Movie*, 1936. See page 93.
Page 114: Detail of Jackson Pollock, *Number 27*, 1950. See page 126.
Page 156: Detail of Andy Warhol, *Ethel Scull 36 Times*, 1963. See page 186.
Page 198: Detail of Cy Twombly, *Untitled*, 1969. See page 223.
Page 232: Detail of Jean-Michel Basquiat, *Hollywood Africans*, 1983. See page 249.
Page 235: Detail of Mike Kelley, *More Love Hours Than Can Ever Be Repaid and
 The Wages of Sin*, 1987. See page 261.

For copyright and Cataloging-in-Publication Data, see page 287.

CONTENTS

FOREWORD

In the early years of the twentieth century, American artists were rarely afforded respect, and American art was barely considered by major museums. The sculptor and art patron Gertrude Vanderbilt Whitney responded to this state of affairs by establishing the Whitney Museum of American Art in New York City. The founding of this new institution was a remarkably bold and progressive step, as the Museum was to be devoted to the support of living American artists and dedicated to promoting an understanding and appreciation of American art. In 1931, the Whitney Museum opened its doors on Eighth Street in a Greenwich Village building that had formerly housed Mrs. Whitney's studio and then the Whitney Studio Club—the immediate predecessor to the formally established Museum.

The Museum began its life with a magnificent gift from its founder and chief benefactor. As an artist-colleague and friend to many New York artists—who in those days lived and worked mostly in Lower Manhattan—Mrs. Whitney had amassed a collection of nearly seven hundred works of art, including many today considered masterpieces, by such artists as George Bellows, John Sloan,

and Edward Hopper. This inaugural group still forms the core of the Whitney Museum's Permanent Collection, and you will find many of their works reproduced in this wonderful tiny volume.

Throughout the decades, scores of individual collectors and patrons have added to the great public collection begun by Mrs. Whitney, and this handbook also pays homage to their largesse. But no group has been more generous than American artists themselves, as they continue to respond to the Museum's ongoing commitment to the extraordinary and constantly changing art of this century.

We sincerely hope that readers of this compact treasury will be encouraged to visit the Whitney Museum of American Art and see for themselves the great works that have helped to define this as the American Century. And we hope that those who already know the Museum's programs and exhibitions will visit again and again to see how American art and American artists evolve in the twenty-first century.

David A. Ross
Director

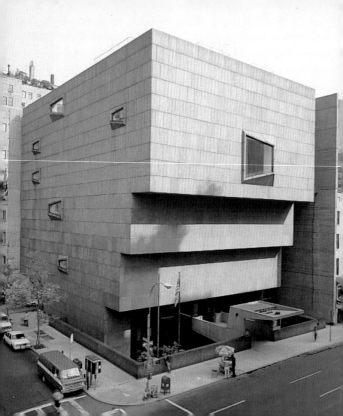

INTRODUCTION

The Whitney Museum houses one of the world's foremost collections of twentieth-century American art. The Permanent Collection of some eleven thousand works encompasses paintings, sculptures, multimedia installations, drawings, prints, and photographs. The Museum was founded in 1931 with a core group of seven hundred art objects, many of them from the personal collection of founder Gertrude Vanderbilt Whitney; others were purchased by Mrs. Whitney at the time of the opening to provide a more thorough overview of American art in the early decades of the century. Mrs. Whitney favored the art of the revolutionary realist artists derisively called the Ashcan School, among them John Sloan, George Luks, and Everett Shinn, as well as American Scene painters such as Edward Hopper, John Steuart Curry, and Thomas Hart Benton. However, many important works by early modernist artists—among them Stuart Davis, Charles Demuth, Charles Sheeler, and Max Weber—were also part of her initial gift. Virtually all the works collected by the Museum for the next twenty years came through the generosity of Mrs. Whitney.

Although the Whitney's acquisition budget was always rather modest, the Museum made the most of its resources by purchasing the work of living artists, particularly young and lesser-known artists. It has been a long-standing tradition of the Whitney to purchase works from the Museum's Annual and Biennial exhibitions, which began in 1932 to showcase recent American art. A number of the Whitney's masterpieces came from these exhibitions, including works by Arshile Gorky, Stuart Davis, Reginald Marsh, Philip Guston, and Jasper Johns. Even today, the Museum continues to acquire works by contemporary artists from Biennials; works reproduced in this volume by Mike Kelley, Alison Saar, and Matthew Barney are among them.

Following Mrs. Whitney's death, and the death of the Museum's first director, Juliana Force, it was soon evident that to keep pace with the burgeoning artistic activity in the United States, the Whitney needed to substantially augment its acquisition funds. In 1956, a group of supporters formed the Friends of the Whitney Museum of American Art. This organization was led by ardent collectors and benefactors of American art: Seymour H. Knox, Mrs. Albert List, Milton Lowenthal, Roy R. Neuberger, Duncan Phillips, Nelson A. Rockefeller, David M. Solinger, and Hudson D. Walker. The Friends were responsible for acquiring some of the most spectacular

paintings and sculptures represented in the collection. Without works such as Edward Hopper's *Second Story Sunlight,* David Smith's *Lectern Sentinel,* Franz Kline's *Mahoning,* Willem de Kooning's *Door to the River,* and Stuart Davis' *The Paris Bit,* as well as more than a hundred others purchased by the Friends, the Whitney today would not have a collection of such high caliber, particularly in the area of abstract art.

In addition to Mrs. Whitney's donations, the Museum's holdings have been greatly enriched through the generous gifts of other major collectors. Each of these contributions has indelibly marked the Whitney's overall collection with a distinctive, personal character. Among the most important of these collectors were Howard and Jean Lipman. Beginning in the 1960s, they donated an extraordinary selection of more than one hundred sculptures, creating one of the strongest museum collections of post–World War II American sculpture. Among the Lipmans' gifts was a large group of works by Alexander Calder and Lucas Samaras, as well as masterpieces by Donald Judd, Dan Flavin, Claes Oldenburg, Louise Nevelson, and George Segal. In 1987, the Museum received more than sixty works, primarily post-1945 painting, from the Lawrence H. Bloedel Bequest. These include highly significant canvases by Milton Avery, William Baziotes, Georgia O'Keeffe, and Fairfield Porter.

Most recently, the Museum's late trustee Charles H. Simon left the Museum seventy-five pieces, including seventeen paintings and watercolors by John Marin. Now, thanks to Simon, the Whitney collection encompasses the full range of Marin's achievement, both in oils and watercolors, from the turn of the century until the artist's death in 1953.

As young artists, Edward Hopper and Reginald Marsh began showing their art in the 1920s at the Whitney Studio Club, the Museum's predecessor, and both continued to exhibit their work at the Museum. In appreciation of the Whitney's enduring support of their art, Josephine Hopper and Felicia Marsh, the artists' widows, made substantial bequests of their husbands' works to the Museum. Today, the Whitney holds the world's largest collection of Hopper's art, consisting of more than twenty-five hundred oils and works on paper. The Museum's Marsh collection is unparalleled—nearly two hundred works in all media, among them a number of the artist's best-known paintings, such as *Twenty Cent Movie* and *Why Not Use the "L"?*.

Despite its realist origins, the Whitney Museum has long sought to assemble a collection that would offer a comprehensive picture of twentieth-century American art through a cross-section of artists working in a range of styles. Although the collection is characterized by its breadth, it is equally recognized for its in-depth commit-

12

ment to the work of a number of artists. In addition to the Hopper and Marsh collections, the Whitney has the largest body of work by Alexander Calder in any museum, ranging from the ever popular *Circus* and Surrealist-inspired pieces of the 1940s to large-scale mobiles and stabiles. Other in-depth concentrations include major holdings by Marsden Hartley, Georgia O'Keeffe, Charles Burchfield, Stuart Davis, Gaston Lachaise, Louise Nevelson, and Agnes Martin.

The Whitney Museum has added nearly one-third more exhibition space for its collection through the renovation of its landmark Marcel Breuer building. The more than ten new galleries provide the Museum with its first opportunity to exhibit highlights from its Permanent Collection on a permanent basis. In addition to a historical overview of American art to 1950, the installation features individual galleries devoted to the works of Edward Hopper, Alexander Calder, and Georgia O'Keeffe. We hope that the works presented in this volume will serve as an incentive to see the originals.

Adam D. Weinberg
Curator, Permanent Collection

ASHCAN AND EARLY CENTURY

Gertrude Vanderbilt Whitney and Juliana Force, the first director of the Whitney Museum, long supported many of the rebels who were derisively grouped as the Ashcan School—artists who focused on seemingly insignificant aspects of urban life, painted in a loose, brushy, realist mode. John Sloan, William Glackens, and Robert Henri brazenly recorded tenements, parks, and music halls, subjects then considered unworthy of fine art. When The Eight, as the Ashcan artists were formally called, held their one and only exhibition at the Macbeth Galleries in 1908, Mrs. Whitney purchased four of the seven paintings sold, among them Everett Shinn's *Revue* (page 26), an act that artist John Sloan considered almost as radical as the making of such frank, unidealized works.

The art produced by The Eight in fact encompassed a range of styles, from Maurice Prendergast's colorful, Post-Impressionist canvases (page 18) and Arthur B. Davies' ethereal, idyllic landscapes (page 34) to William Glackens' vision of bourgeois nightlife (page 19) and John Sloan's paeans to the lower classes (page 22).

John Sloan, like a number of his Ashcan colleagues, was trained as a newspaper illustrator. The Museum is fortunate to possess superb holdings of his etchings, as well as his paintings, which reveal his considerable skills as narrator. Peggy Bacon (page 23), Glenn O. Coleman (page 32), and George Bellows, working in the spirit of the Ashcan School, also used reportage as an antidote to the stiff, humorless academicism of turn-of-the-century American art. Bellows' dramatic "snapshot" of the celebrated Dempsey and Firpo fight, the last of six paintings the artist produced on this subject, is one of the masterworks of early twentieth-century American painting (page 33).

Edward Hopper, who studied with Robert Henri, the dynamic leader of The Eight, is represented here by an uncharacteristic but important work painted in a manner reminiscent of Edgar Degas. *Soir Bleu* (page 30) was exhibited in 1914 and given a rather negative review. As a result, Hopper never showed it again during his lifetime. Guy Pène du Bois, a classmate and friend of Hopper, was acknowledged for his satirical depictions of the well-bred, as in his icy depiction of the woman in *Opera Box* (page 31).

The Whitney Museum's collection of early twentieth-century sculpture is distinguished by excellent holdings of works by two émigré artists, Elie Nadelman and Gaston

Lachaise. *Tango* (page 28), Nadelman's extraordinary carved and painted cherrywood sculpture, reveals the artist's penchant for folk art and his desire to celebrate a dance that enraptured his generation. Lachaise's monumental *Standing Woman* (page 35) is one of the sculptor's greatest achievements. This larger-than-life bronze was made in homage to his wife, Isabel Dutaud Nagle, whom he sculpted throughout his lifetime.

MAURICE PRENDERGAST (1858–1924).
The Promenade, 1913.
Oil on canvas, 30 x 34 in. (76.2 x 86.4 cm).

WILLIAM J. GLACKENS (1870–1938).
Hammerstein's Roof Garden, c. 1901.
Oil on canvas, 30 x 25 in. (76.2 x 63.5 cm).

JOHN SLOAN (1871–1951).
The Hawk (Yolande in Large Hat), 1910.
Oil on canvas, 26⅚₁₆ x 32¼ in. (66.8 x 81.9 cm).

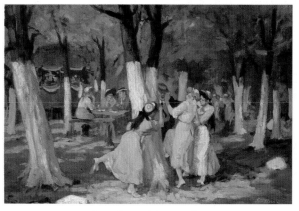

JOHN SLOAN (1871–1951).
The Picnic Grounds, 1906–7.
Oil on canvas, 24 x 36 in. (61 x 91.4 cm).

JOHN SLOAN (1871–1951).
Turning Out the Light, from the series *New York City Life,* 1905.
Etching: sheet, 7¹³⁄₁₆ x 11¼ in. (19.8 x 28.6 cm);
plate, 4⅝ x 6⅝ in. (11.7 x 16.8 cm).

PEGGY BACON (1895–1987).
The Whitney Studio Club, 1925.
Drypoint: sheet, 9 x 11 in. (22.9 x 27.9 cm);
plate, 5¹³⁄₁₆ x 9 in. (14.8 x 22.9 cm).

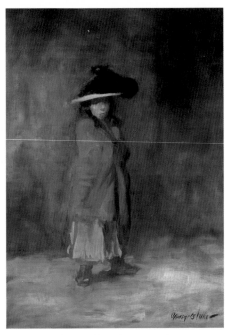

GEORGE LUKS (1867–1933).
The Little Gray Girl, 1905.
Oil on canvas, 36 x 26 in. (91.4 x 66 cm).

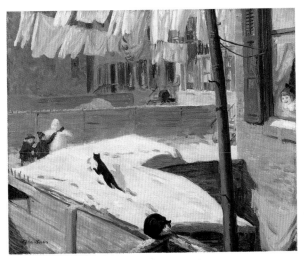

John Sloan (1871–1951).
Backyards, Greenwich Village, 1914.
Oil on canvas, 26 x 32 in. (66 x 81.3 cm).

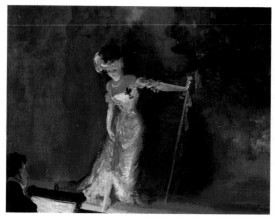

EVERETT SHINN (1876–1953).
Revue, 1908.
Oil on canvas, 18 x 24 in. (45.7 x 61 cm).

GEORGE LUKS (1867–1933).
Armistice Night, 1918.
Oil on canvas, 37 x 68¾ in. (94 x 174.6 cm).

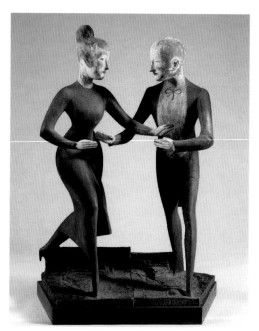

ELIE NADELMAN (1882–1946).
Tango, c. 1919.
Painted cherrywood and gesso, 3 units, 35⅞ x 26 x 13⅞ in.
(91.1 x 66 x 35.2 cm) overall.

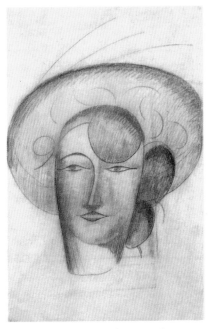

ELIE NADELMAN (1882–1946).
Head of a Woman with Hat, c. 1923–25.
Graphite on tracing vellum, 16½ x 10¾ in. (41.9 x 27.3 cm).

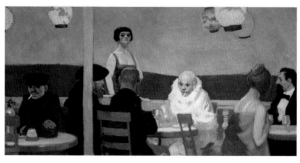

EDWARD HOPPER (1882–1967).
Soir Bleu, 1914.
Oil on canvas, 36 x 72 in. (91.4 x 182.9 cm).

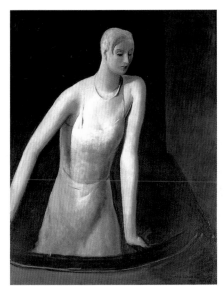

Guy Pène du Bois (1884–1958).
Opera Box, 1926.
Oil on canvas, 57½ x 45¼ in. (146.1 x 114.9 cm).

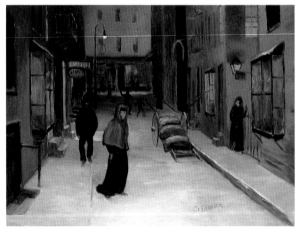

GLENN O. COLEMAN (1887–1932).
Minetta Lane, Night, n.d.
Oil on canvas, 24⅛ x 32⅛ in. (61.3 x 81.6 cm).

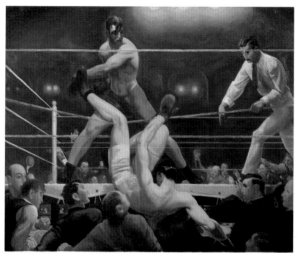

GEORGE BELLOWS (1882–1925).
Dempsey and Firpo, 1924.
Oil on canvas, 51 x 63¼ in. (129.5 x 160.7 cm).

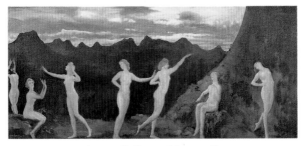

ARTHUR B. DAVIES (1862–1928).
Crescendo, 1910.
Oil on canvas, 18 x 40 in. (45.7 x 101.6 cm).

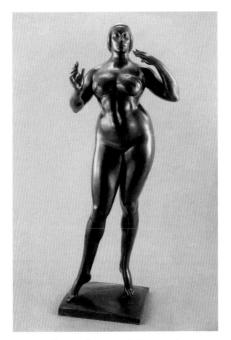

GASTON LACHAISE (1882–1935).
Standing Woman, 1912–27.
Bronze, 69½ x 26¹⁵⁄₁₆ x 17 in. (176.5 x 68.4 x 43.2 cm).

AMERICAN MODERNISM

The advent of modernism in America is generally associated with the Armory Show of 1913—an exhibition that catapulted American art out of cultural isolationism into a period of unprecedented growth and experimentation. The Armory Show placed American artists in the context of international movements and in the company of such European masters of abstraction as Cézanne, Matisse, and Picasso. And while Americans continued to study European advancements, they also actively pursued an indigenous style and subject matter.

For many of these artists, it was the American city, New York in particular, that became symbolic of the new age. The bridges, skyscrapers, elevated trains, surging crowds, and frenetic pace became paradigmatic of the energetic and dynamic aspirations of vanguard art. Max Weber's celebrated painting *Chinese Restaurant* (page 40 and detail, opposite) merges his European-influenced Synthetic Cubist style with what was for Weber a distinctly American subject—the colors and patterns, hustle and flurry, of a visit to New York's Chinatown. Joseph Stella rendered what he believed to be the quintessential American achievement in the majestic solidity and vibrant colors

of *The Brooklyn Bridge: Variation on an Old Theme* (page 73). John Marin likewise fell under the spell of that grand urban icon. His *Region of Brooklyn Bridge Fantasy* (page 48) is a spontaneously rendered watercolor of the dynamic growth of the urban scene.

Man Ray, on the other hand, eschewing an expressionist idiom in favor of wry Dada commentary, constructed a homage to the burgeoning skyscrapers of his adopted city in the form of a simple construction of chrome-plated wooden slats and a carpenter's clamp (page 43). Arthur Dove took this early assemblage technique to a more complex level in his witty, irreverent satire of art-world pundits, *The Critic* (page 44).

Other artists in the first few decades of the century, equally concerned with finding a visual vocabulary with which to express their modern ideas, took inspiration from nature and its perceived moral and spiritual superiority. Georgia O'Keeffe's *Black and White* (page 51) and *The White Calico Flower* (page 53) demonstrate her mastery at turning natural reality into abstract symbol, creating some of the most original contributions to American modernism.

By the mid- to late 1920s, a group of modernists approached the changing urban and industrial landscape, transforming it into precisely structured forms that became paeans to American technological advancement.

The work of these Precisionists, as they came to be called, is characterized in the Whitney's collection by such masterworks as Charles Demuth's *My Egypt* (page 64) and Charles Sheeler's *River Rouge Plant* (page 65). In sculpture, the industrial streamlining and modern materials in John Storrs' *Forms in Space #1* (page 66) marks an important breakthrough for three-dimensional abstraction in America.

Stuart Davis' fifty-year career is closely allied with the history of the Whitney Museum. First exhibiting in 1917 at the Whitney Studio Club, Davis went on to enjoy two retrospectives at the Museum and inclusion in numerous exhibitions of the collection. His radical, early non-objective abstraction, *Egg Beater No. 1* (page 72) and his *House and Street* (page 71), with its distinct cinematic references, are powerful testaments to the sophistication of American abstractionists by the end of the 1920s.

There is no modernist sculptor so closely allied with the Whitney Museum as Alexander Calder. The Museum's collection includes more than one hundred works by this important and beloved American master. While *Calder's Circus* (page 59) remains the delight of audiences of all ages, the fluid biomorphic abstraction of *Wooden Bottle with Hairs* (page 56) and the subtle balance of forms in such works as *Calderberry Bush* (page 57) attest to the diversity and breadth of Calder's vision.

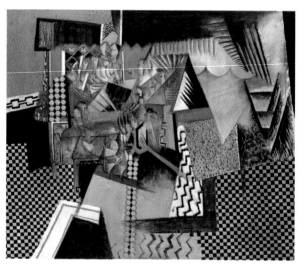

Max Weber (1881–1961).
Chinese Restaurant, 1915.
Oil on canvas, 40 x 48 in. (101.6 x 121.9 cm).

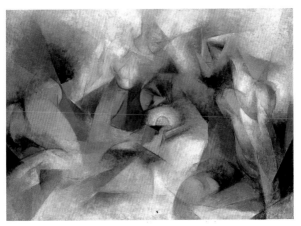

STANTON MACDONALD-WRIGHT (1890–1973).
"Oriental." Synchromy in Blue-green, 1918.
Oil on canvas, 36 x 50 in. (91.4 x 127 cm).

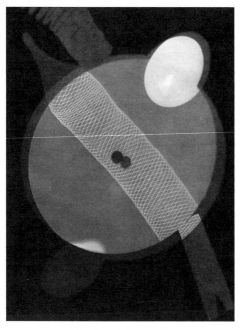

MAN RAY (1890-1976).
Contrasted Circular Forms with Pair of Optical Black Dots, 1923.
Rayograph, 9⅜ x 7¹⁄₁₆ in. (23.8 x 17.9 cm).

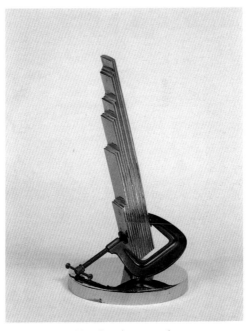

MAN RAY (1890–1976).
New York, 1917/1966 (1966 recreation of destroyed
1917 wood original). Chromed and painted bronze,
17 x 9⁵⁄₁₆ x 9⁵⁄₁₆ in. (43.2 x 23.7 x 23.7 cm).

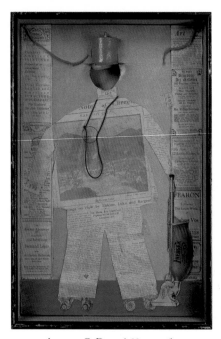

Arthur G. Dove (1880–1946).
The Critic, 1925.
Collage, 19¾ x 13½ x 3⅜ in. (50.2 x 34.3 x 9.2 cm).

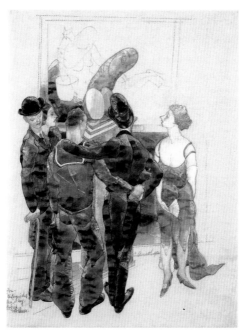

CHARLES DEMUTH (1883–1935).
Distinguished Air, 1930.
Watercolor on paper, 14 x 12 in. (35.6 x 30.5 cm).

MARSDEN HARTLEY (1877–1943).
Painting, Number 5, 1914–15.
Oil on canvas, 39½ x 31¾ in. (100.3 x 80.6 cm).

MARSDEN HARTLEY (1877-1943).
Landscape, New Mexico, 1919-20.
Oil on canvas, 28 x 36 in. (71.1 x 91.4 cm).

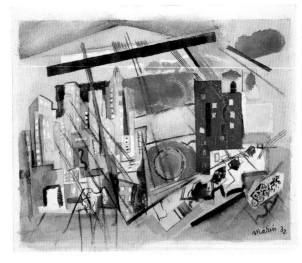

JOHN MARIN (1870–1953).
Region of Brooklyn Bridge Fantasy, 1932.
Watercolor on paper, 18¾ x 22¼ in. (47.6 x 56.5 cm).

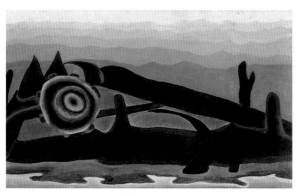

ARTHUR G. DOVE (1880–1946).
Ferry Boat Wreck, 1931.
Oil on canvas, 18 x 30 in. (45.7 x 76.2 cm).

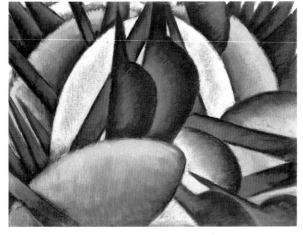

ARTHUR G. DOVE (1880–1946).
Plant Forms, c. 1912.
Pastel on canvas, 17¼ x 23⅞ in. (43.8 x 60.6 cm).

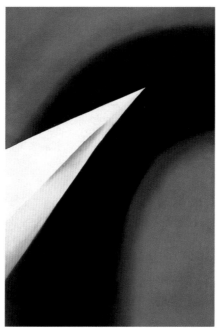

GEORGIA O'KEEFFE (1887–1986).
Black and White, 1930.
Oil on canvas, 36 x 24 in. (91.4 x 61 cm).

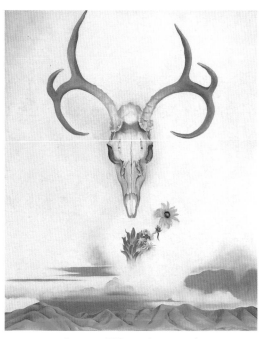

GEORGIA O'KEEFFE (1887–1986).
Summer Days, 1936.
Oil on canvas, 36 x 30 in. (91.4 x 76.2 cm).

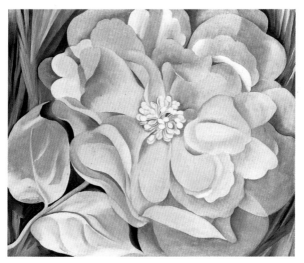

GEORGIA O'KEEFFE (1887–1986).
The White Calico Flower, 1931.
Oil on canvas, 30 x 36 in. (76.2 x 91.4 cm).

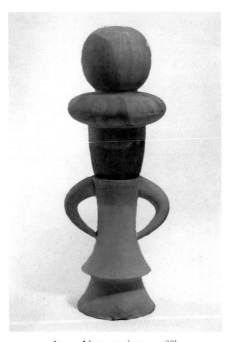

ISAMU NOGUCHI (1904–1988).
The Queen, 1931.
Terracotta, 45½ x 16 x 16 in. (115.6 x 40.6 x 40.6 cm).

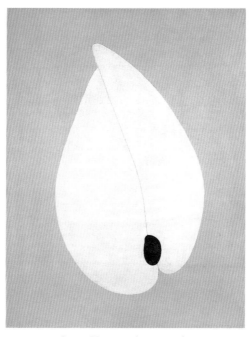

Isamu Noguchi (1904–1988).
Paris Abstraction, 1927–28.
Gouache on paper, 25¹¹⁄₁₆ x 19¾ in. (65.2 x 50.2 cm).

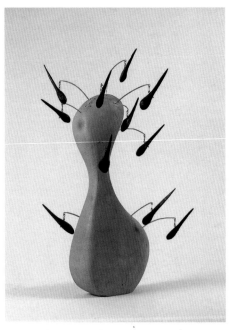

ALEXANDER CALDER (1898–1976).
Wooden Bottle with Hairs, 1943.
Wood and wire, 22⅜ x 13 x 12 in. (56.8 x 33 x 30.5 cm) overall.

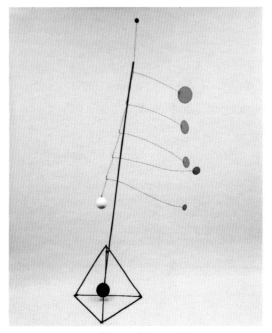

ALEXANDER CALDER (1898–1976).
Calderberry Bush, 1932.
Painted steel rod, wire, wood, and sheet aluminum, dimensions
variable: 88½ x 33 x 47½ in. (224.8 x 83.8 x 120.7 cm) with base.

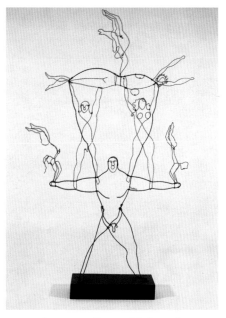

ALEXANDER CALDER (1898–1976).
The Brass Family, 1927.
Brass wire and painted wood, 66⅜ x 40 x 8 in.
(168.6 x 101.6 x 20.3 cm).

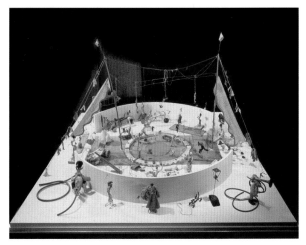

ALEXANDER CALDER (1898–1976).
Calder's Circus, 1926–31. Mixed media: wire, wood, metal, cloth,
yarn, paper, cardboard, leather, string, rubber tubing, corks, buttons,
rhinestones, pipe cleaners, and bottle caps, dimensions variable:
54 x 94¼ x 94¼ in. (137.2 x 239.4 x 239.4 cm) overall.

Lyonel Feininger (1871–1956).
Gelmeroda, VIII, 1921.
Oil on canvas, 39¼ x 31¼ in. (99.7 x 79.4 cm).

OSCAR BLUEMNER (1867–1938).
A Situation in Yellow, 1933.
Oil on canvas, 36 x 50½ in. (91.4 x 128.3 cm).

CHARLES G. SHAW (1892–1974).
Self-Portrait, c. 1930.
Oil on canvas, 24 x 20 in. (61 x 50.8 cm).

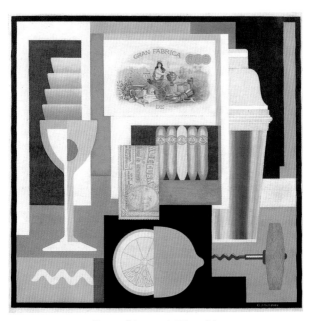

GERALD MURPHY (1888–1964).
Cocktail, 1927.
Oil on canvas, 29 1/16 x 29 7/8 in. (73.8 x 75.9 cm).

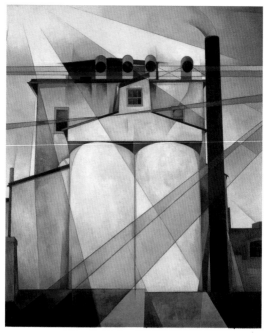

CHARLES DEMUTH (1883–1935).
My Egypt, 1927.
Oil on composition board, 35¾ x 30 in. (90.8 x 76.2 cm).

Charles Sheeler (1883–1965).
River Rouge Plant, 1932.
Oil on canvas, 20 x 24⅛ in. (50.8 x 61.3 cm).

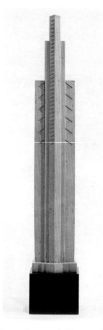

JOHN STORRS (1885–1956).
Forms in Space #1, c. 1924.
Marble, 76¾ x 12⅝ x 8⅝ in.
(194.9 x 32.1 x 21.9 cm), without base.

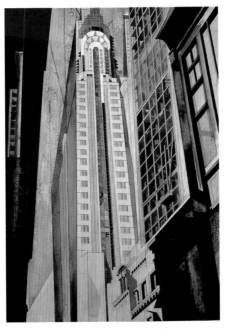

EARLE HORTER (1881–1940).
The Chrysler Building Under Construction, 1931.
Ink and watercolor on paper, 20¼ x 14¾ in. (51.4 x 37.5 cm).

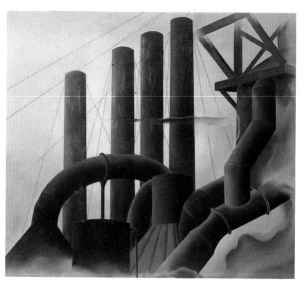

ELSIE DRIGGS (1898–1992).
Pittsburgh, 1927.
Oil on canvas, 34¼ x 40 in. (87 x 101.6 cm).

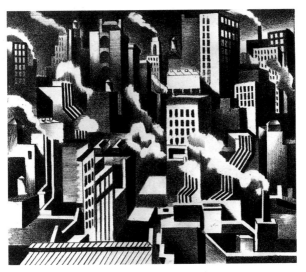

JAN MATULKA (1890–1972).
New York Evening, 1925.
Lithograph: sheet, 14⁷⁄₁₆ x 19½ in. (36.7 x 49.5 cm);
image, 13¼ x 16 in. (33.7 x 40.6 cm).

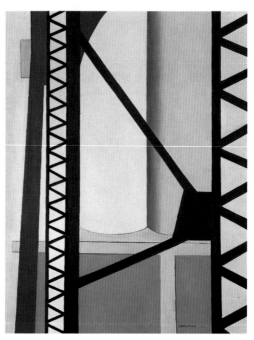

RALSTON CRAWFORD (1906–1978).
Grain Elevators from the Bridge, 1942.
Oil on canvas, 50 x 40 in. (127 x 101.6 cm).

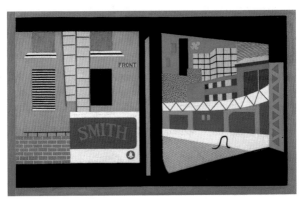

STUART DAVIS (1892–1964).
House and Street, 1931.
Oil on canvas, 26 x 42¼ in. (66 x 107.3 cm).

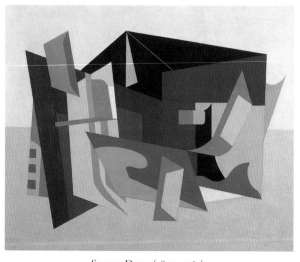

STUART DAVIS (1892–1964).
Egg Beater No. 1, 1927.
Oil on canvas, 29⅛ x 36 in. (74 x 91.4 cm).

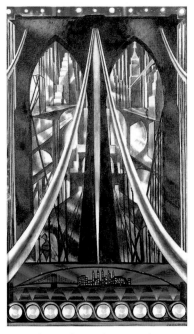

JOSEPH STELLA (1877–1946).
The Brooklyn Bridge: Variation on an Old Theme, 1939.
Oil on canvas, 70 x 42 in. (177.8 x 106.7 cm).

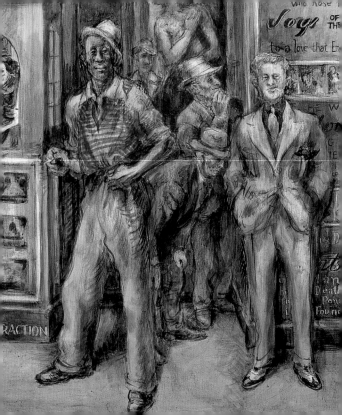

AMERICAN SCENE
AND SURREALISM

The Whitney Museum opened in 1931 at the height of the Great Depression, when a conservative mood—financial, moral, and artistic—prevailed. Many artists found solace in a return to more traditional subject matter and indigenous American artistic styles. Gertrude Vanderbilt Whitney, herself a realist sculptor, embraced the art of this period, broadly termed the American Scene. Thomas Hart Benton (page 86), John Steuart Curry (page 87), and Grant Wood (pages 88 and 89), the Midwestern Regionalists, enjoyed considerable popularity during the 1930s as the desire grew for patriotic and often nostalgic images, exalting our native folklore and agrarian past.

In the cities, other images of this troubled time served documentary and polemical purposes, exposing the social inequities, political injustices, and sense of hopelessness that threatened the stability of American society. Ben Shahn's powerful portrayal of the anarchists Sacco and Vanzetti—lying in their coffins before the courthouse in which they were sentenced to death—is a somber reflection on a

controversial moment in our judicial history (page 102). The psychological intensity of George Tooker's *The Subway* (page 103), with its wary, frightened figures, tells a haunting story of urban decline and social dysfunction.

Reginald Marsh, one of the seminal chroniclers of the 1930s American scene, had his first one-artist exhibition at the Whitney Studio Club in 1924 and continued to participate in exhibitions and programs at the Museum until his death in 1954. Thanks to the generous 1978 bequest of paintings, watercolors, prints, and drawings by the artist's widow, the Museum's collection is rich in every aspect of Marsh's spirited and poignant work. His Depression-era glimpses into everyday urban life in *Why Not Use the "L"?* and *Bread Line—No One Has Starved* (pages 94 and 95), as well as his chronicles of middle-class amusements in such works as *Twenty Cent Movie* (page 93, and detail, page 74), help form the core of the Museum's strong holdings of urban realism.

Likewise, it was Gertrude Vanderbilt Whitney's early interest in the work of Edward Hopper, who had his first one-artist show in 1920 at the Whitney Studio Club and another two years later, that fostered an important relationship between the artist and the Whitney Museum. This connection was later further strengthened by curator and director Lloyd Goodrich's tenacious support of Hopper's

art. Iconic in their stillness and psychological force, paintings by Edward Hopper such as *Second Story Sunlight* and *A Woman in the Sun* (pages 78 and 82), along with the more than twenty-five hundred paintings, watercolors, drawings, and prints that form the Hopper Bequest to the Museum, have made the Whitney a center for the study and exhibition of this important American artist's life and work.

By the end of the 1930s, European Surrealism began to exert a profound impact on American art. Liberated by the movement's emphasis on fantasy and chance occurrence, artists such as Man Ray explored a new formal vocabulary based on purposeful distortions of scale and narrative (page 113). Others, among them Joseph Cornell, constructed private worlds of assemblaged found objects and personal reference in such diminutive but complex dramas as *Rose Castle* (page 112). But it was the fluid organicism in such works as Arshile Gorky's *The Betrothal, II* (page 111), born of a Surrealist-inspired biomorphism, that by mid-century came to characterize much of American abstraction.

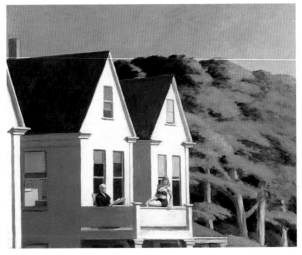

EDWARD HOPPER (1882-1967).
Second Story Sunlight, 1960.
Oil on canvas, 40 x 50 in. (101.6 x 127 cm).

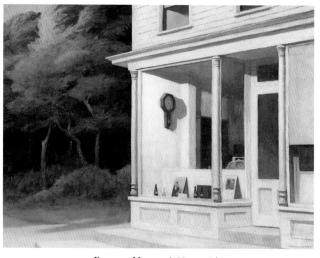

EDWARD HOPPER (1882–1967).
Seven A.M., 1948.
Oil on canvas, 30 x 40 in. (76.2 x 101.6 cm).

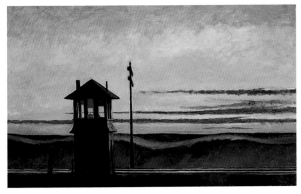

EDWARD HOPPER (1882–1967).
Railroad Sunset, 1929.
Oil on canvas, 28¼ x 47¾ in. (71.8 x 121.3 cm).

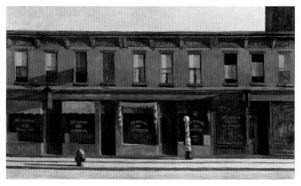

EDWARD HOPPER (1882–1967).
Early Sunday Morning, 1930.
Oil on canvas, 35 x 60 in. (88.9 x 152.4 cm).

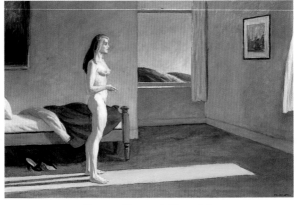

EDWARD HOPPER (1882–1967).
A Woman in the Sun, 1961.
Oil on canvas, 40 x 60 in. (101.6 x 152.4 cm).

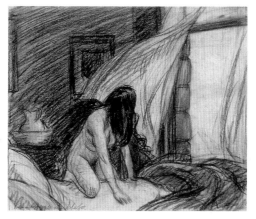

EDWARD HOPPER (1882–1967).
Study for Evening Wind, 1921.
Conté and charcoal on paper, 10 x 13^{15}⁄$_{16}$ in. (25.4 x 35.4 cm).

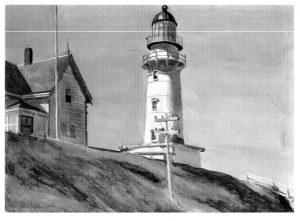

EDWARD HOPPER (1882–1967).
Light at Two Lights, 1927.
Watercolor on paper, 13$^{15}/_{16}$ x 20 in. (35.4 x 50.8 cm).

EDWARD HOPPER (1882–1967).
American Landscape, 1920.
Etching: sheet, 13⅜ x 18¼ in. (34 x 46.4 cm);
plate, 7⁵⁄₁₆ x 12⁵⁄₁₆ in. (18.6 x 31.3 cm).

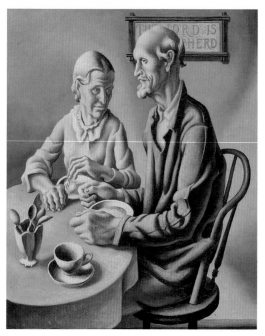

THOMAS HART BENTON (1889–1975).
The Lord Is My Shepherd, 1926.
Tempera on canvas, 33¼ x 27⅜ in. (84.5 x 69.5 cm).

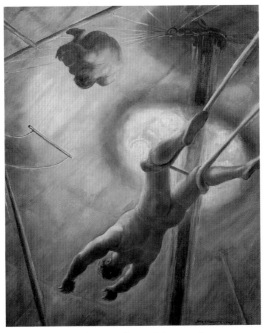

JOHN STEUART CURRY (1897–1946).
The Flying Codonas, 1932.
Tempera and oil on composition board, 36 x 30 in. (91.4 x 76.2 cm).

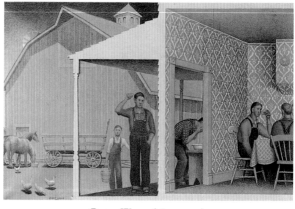

GRANT WOOD (1892–1942).
Dinner for Threshers (Left Section), 1933.
Graphite and gouache on paper, 17¾ x 26¾ in. (45.1 x 67.9 cm).

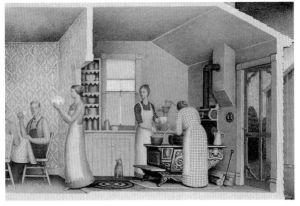

GRANT WOOD (1892–1942).
Dinner for Threshers (Right Section), 1933.
Graphite and gouache on paper, 17¾ x 26¾ in. (45.1 x 67.9 cm).

CHARLES BURCHFIELD (1893–1967).
Noontide in Late May, 1917.
Watercolor and gouache on paper, 21⅝ x 17½ in. (54.9 x 44.5 cm).

ANDREW WYETH (b. 1917).
Winter Fields, 1942.
Tempera on canvas, 17¼ x 41 in. (43.8 x 104.1 cm).

WILLIAM H. JOHNSON (1901–1970).
Blind Singer, c. 1942.
Screenprint, 17½ x 11⁹⁄₁₆ in. (44.5 x 29.4 cm).

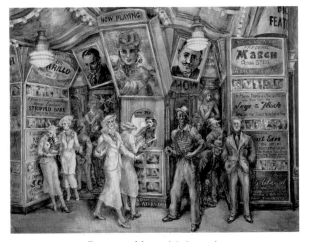

Reginald Marsh (1898–1954).
Twenty Cent Movie, 1936.
Egg tempera on composition board, 30 x 40 in. (76.2 x 101.6 cm).

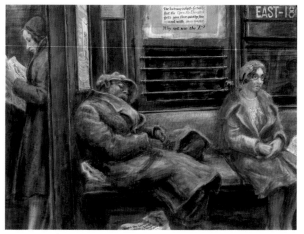

REGINALD MARSH (1898–1954).
Why Not Use the "L"?, 1930.
Egg tempera on canvas, 36 x 48 in. (91.4 x 121.9 cm).

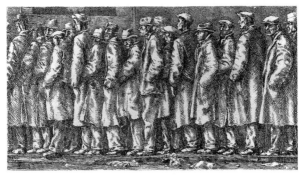

REGINALD MARSH (1898–1954).
Bread Line—No One Has Starved, 1932.
Etching and engraving: sheet, 9⅞ x 14⅛ in. (25.1 x 35.9 cm)
irregular; plate, 6⅜ x 11⅞ in. (16.2 x 30.2 cm).

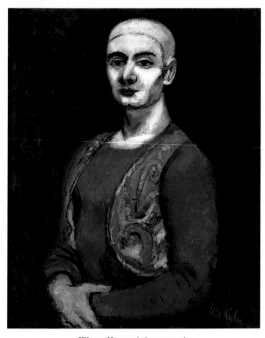

WALT KUHN (1877–1949).
The Blue Clown, 1931.
Oil on canvas, 30 x 25 in. (76.2 x 63.5 cm).

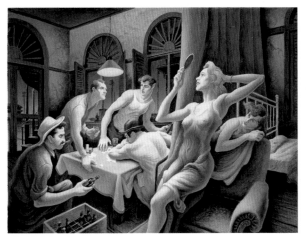

THOMAS HART BENTON (1889–1975).
Poker Night (from "A Streetcar Named Desire"), 1948.
Tempera and oil on panel, 36 x 48 in. (91.4 x 121.9 cm).

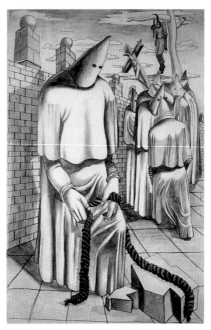

PHILIP GUSTON (1913–1980).
Drawing for Conspirators, 1930.
Graphite, ink, colored pencil, and crayon on paper,
22½ x 14½ in. (57.2 x 36.8 cm).

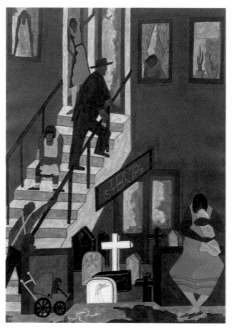

JACOB LAWRENCE (b. 1917).
Tombstones, 1942.
Gouache on paper, 28¾ x 20½ in. (73 x 52.1 cm).

JACOB LAWRENCE (b. 1917).
War Series: The Letter, 1946.
Egg tempera on composition board, 20 x 16 in. (50.8 x 40.6 cm).

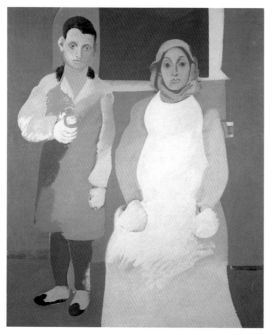

Arshile Gorky (1904–1948).
The Artist and His Mother, c. 1926–36.
Oil on canvas, 60 x 50 in. (152.4 x 127 cm).

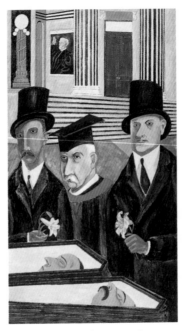

BEN SHAHN (1898–1969).
The Passion of Sacco and Vanzetti, 1931–32,
from the series *Sacco-Vanzetti*. Tempera on canvas,
84½ x 48 in. (214.6 x 121.9 cm).

GEORGE TOOKER (b. 1920).
The Subway, 1950.
Egg tempera on composition board,
18⅛ x 36⅛ in. (46 x 91.8 cm).

PAUL CADMUS (b. 1904).
Sailors and Floosies, 1938.
Oil and tempera on panel, 25 x 39½ in. (63.5 x 100.3 cm).

YASUO KUNIYOSHI (1889–1953).
I'm Tired, 1938.
Oil on canvas, 40¼ x 31 in. (102.2 x 78.7 cm).

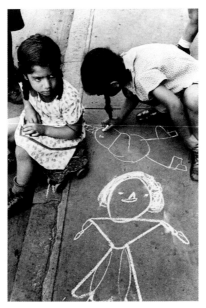

HELEN LEVITT (b. 1913).
Street Drawing, c. 1940, from the book *In the Street*.
Gelatin silver print, 10⅞ x 7⁵⁄₁₆ in. (27.6 x 18.6 cm).

PHILIP EVERGOOD (1901–1973).
Lily and the Sparrows, 1939.
Oil on composition board, 30 x 24 in. (76.2 x 61 cm).

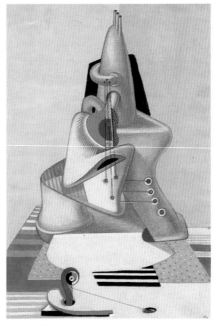

THEODORE ROSZAK (1907–1981).
Metaphysical Structure, 1933.
Crayon, gouache, and ink on paper, 23 x 16⁹⁄₁₆ in. (58.4 x 42.1 cm).

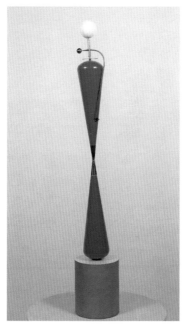

THEODORE ROSZAK (1907–1981).
Bi-Polar in Red, 1940.
Metal, plastic, and wood, 54¼ x 8⅝ x 8⅝ in.
(137.8 x 21.9 x 21.9 cm) overall.

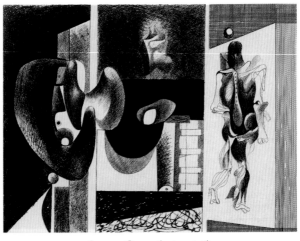

ARSHILE GORKY (1904–1948).
Nighttime, Enigma and Nostalgia, c. 1931–32.
Ink on paper, 24 x 31 in. (61 x 78.7 cm).

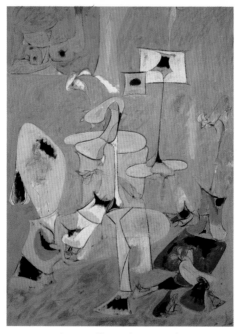

ARSHILE GORKY (1904–1948).
The Betrothal, II, 1947.
Oil on canvas, 50¾ x 38 in. (128.9 x 96.5 cm).

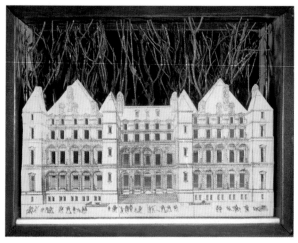

JOSEPH CORNELL (1903-1972).
Rose Castle, 1945.
Wood, glass, mirrors, painted branches, printed paper, painted
wood, and glitter, 11½ x 14¹⁵⁄₁₆ x 4¹⁄₁₆ in. (29.2 x 37.9 x 10.3 cm).

MAN RAY (1890–1976).
La Fortune, 1938.
Oil on canvas, 24 x 29 in. (61 x 73.7 cm).

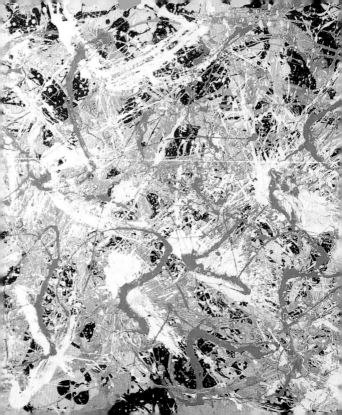

ABSTRACT ART AT MID-CENTURY

Abstract art in the 1950s, though generally believed to have been dominated by Abstract Expressionism, was in fact a battleground of competing styles and artistic tendencies. This moment of American art, as rich in formal innovation as in passionate debate about the nature of abstraction, has long been credited with bringing American art to international prominence.

Abstract Expressionism, or Action Painting, emerged in the years following World War II as a synthesis of both new formal innovations and earlier stylistic influences—the spatial concerns of Cubism, the spontaneity of automatic writing, and the biomorphic forms of Surrealism. The overlapping gestural paint surface, overall patterning, and expressive mastery of Jackson Pollock's *Number 27* (page 126 and detail, opposite) stands as the preeminent declaration of America's growing artistic integrity and strength. Franz Kline's black-and-white abstractions, such as *Mahoning* (page 132), present a starker, more controlled expressionism grounded in an architectonic structure that holds the dynamism of the strokes in check. It was Willem

de Kooning, in his *Woman* series of the mid-1950s (page 130), who first broke with the Abstract Expressionists' reliance on non-objective imagery, creating turbulent and sometimes disturbing abstractions of the human form.

In sculpture, the lines of welded steel in David Smith's *Hudson River Landscape* (page 135) move swiftly through space with the same animation and energy found in contemporaneous Abstract Expressionist painting. His later *Lectern Sentinel* (page 136), however, with strong, geometric forms balancing a reserved frontality, shares a sense of solidity and minimalism with Alexander Calder's mature sculptural stabiles, among them *The Arches* (page 149).

Innovations in technique, such as Helen Frankenthaler's radical process of staining raw canvas with large expanses of color (page 154), resulted in spontaneously applied, floating forms that evoke nature as well as different emotional states. A related sense of quietude can be found in Mark Rothko's classic painting *Four Darks in Red* (page 133), in which a luminous palette of dark red, maroon, and black horizontal rectangles implies a stark landscape.

The art of Burgoyne Diller, who had adopted Piet Mondrian's Neo-Plasticist ideas in the 1930s, became increasingly simplified, iconic, and symmetrical (page 120). Likewise, Ad Reinhardt, who had been part of the American Abstract Artists group of the 1930s, brought abstraction into a purely geometric realm in such works as

Number 17—1953 (page 144). Stuart Davis' important work of the 1950s denied strict geometries in favor of a complex layering of remembered imagery, architectural forms, and overlayed language, numbers, and symbols. The use of such motifs in his masterworks *Owh! in San Paõ* and *The Paris Bit* (pages 118 and 119) presage the Pop Art that emerged in the 1960s.

STUART DAVIS (1892–1964).
Owh! in San Paõ, 1951.
Oil on canvas, 52¼ x 41¾ in. (132.7 x 106 cm).

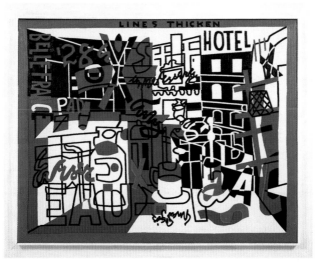

STUART DAVIS (1892–1964).
The Paris Bit, 1959.
Oil on canvas, 46 x 60 in. (116.8 x 152.4 cm).

BURGOYNE DILLER (1906–1965).
First Theme, 1938.
Oil on canvas, 30¹/₁₆ x 30¹/₁₆ in. (76.4 x 76.4 cm).

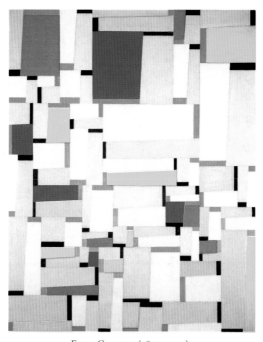

FRITZ GLARNER (1899–1972).
Relational Painting, 1949–51.
Oil on canvas, 65 x 52 in. (165.1 x 132.1 cm).

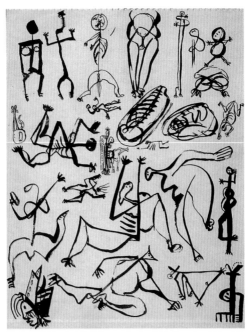

JACKSON POLLOCK (1912–1956).
Untitled, c. 1939–42.
Ink on paper, 18 x 13⅞ in. (45.7 x 35.2 cm) double-sided.

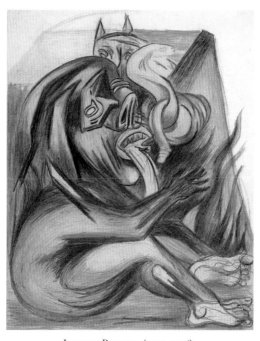

JACKSON POLLOCK (1912–1956).
Untitled, c. 1939–42.
Crayon and graphite on paper, 14 x 11 in. (35.6 x 27.9 cm).

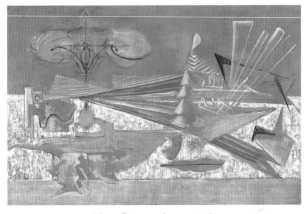

MARK ROTHKO (1903–1970).
Agitation of the Archaic, 1944.
Oil on canvas, 35⅜ x 54¼ in. (89.9 x 137.8 cm).

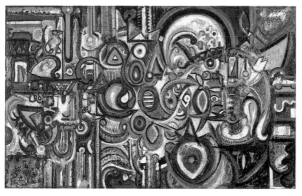

RICHARD POUSETTE-DART (1916–1992).
Within the Room, 1942.
Oil on canvas, 36 x 60 in. (91.4 x 152.4 cm).

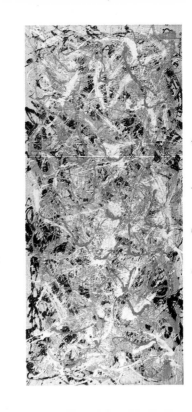

JACKSON POLLOCK (1912–1956).
Number 27, 1950.
Oil on canvas, 49 x 106 in. (124.5 x 269.2 cm).

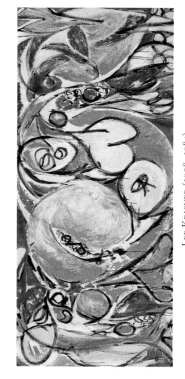

LEE KRASNER (1908–1984).
The Seasons, 1957.
Oil on canvas, 92¾ x 203¾ in. (235.6 x 517.5 cm).

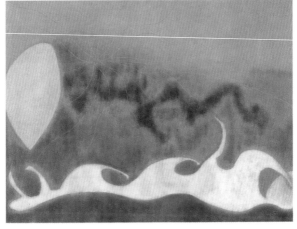

WILLIAM BAZIOTES (1912–1963).
The Beach, 1955.
Oil on canvas, 36 x 48 in. (91.4 x 121.9 cm).

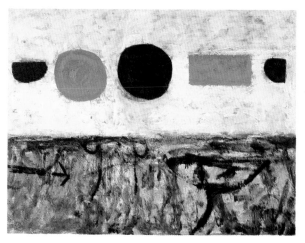

ADOLPH GOTTLIEB (1903–1974).
The Frozen Sounds, Number 1, 1951.
Oil on canvas, 36 x 48 in. (91.4 x 121.9 cm).

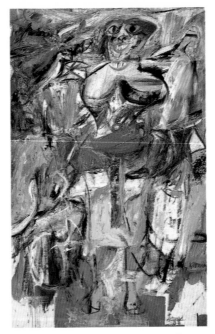

WILLEM DE KOONING (1904–1997).
Woman and Bicycle, 1952–53.
Oil on canvas, 76½ x 49 in. (194.3 x 124.5 cm).

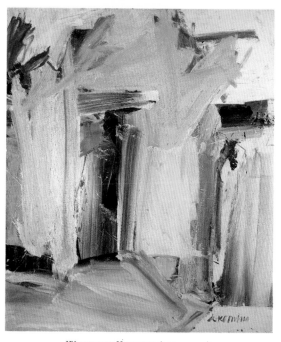

WILLEM DE KOONING (1904–1997).
Door to the River, 1960.
Oil on canvas, 80 x 70 in. (203.2 x 177.8 cm).

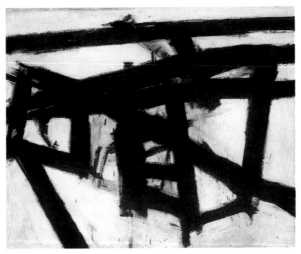

FRANZ KLINE (1910–1962).
Mahoning, 1956.
Oil and paper collage on canvas, 80 x 100 in. (203.2 x 254 cm).

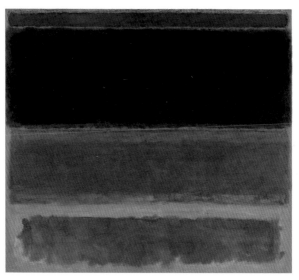

MARK ROTHKO (1903–1970).
Four Darks in Red, 1958.
Oil on canvas, 102 x 116 in. (259.1 x 294.6 cm).

DAVID SMITH (1906–1965).
Eng No. 6, 1952.
Tempera and oil on paper, 29¾ x 42¼ in. (75.6 x 107.3 cm).

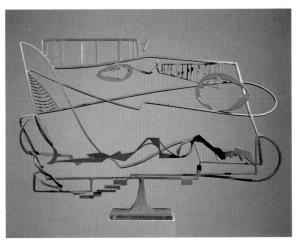

DAVID SMITH (1906–1965).
Hudson River Landscape, 1951.
Welded painted steel and stainless steel, 49¹⁵⁄₁₆ x 73¾ x 16⁹⁄₁₆ in.
(126.8 x 187.3 x 42.1 cm).

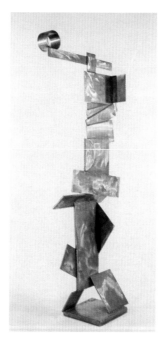

DAVID SMITH (1906–1965).
Lectern Sentinel, 1961.
Stainless steel, 101¾ x 33 x 20½ in. (258.4 x 83.8 x 52.1 cm).

Barnett Newman (1905–1970).
Day One, 1951–52.
Oil on canvas, 132 x 50¼ in. (335.3 x 127.6 cm).

PHILIP GUSTON (1913–1980).
Dial, 1956.
Oil on canvas, 72 x 76 in. (182.9 x 193 cm).

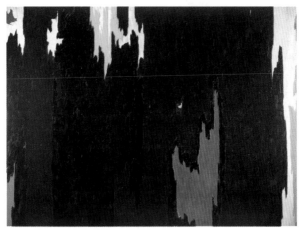

CLYFFORD STILL (1904–1980).
Untitled, 1957.
Oil on canvas, 112 x 154 in. (284.5 x 391.2 cm).

ROBERT MOTHERWELL (1915–1991).
N.R.F. Collage, Number 2, 1960.
Oil and collage on paper, 28⅛ x 21½ in. (71.4 x 54.6 cm).

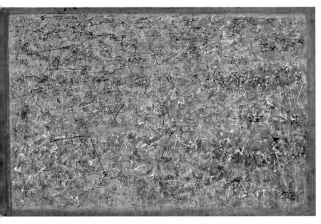

MARK TOBEY (1890–1976).
Universal Field, 1949.
Tempera and pastel on cardboard, 28 x 44 in. (71.1 x 111.8 cm).

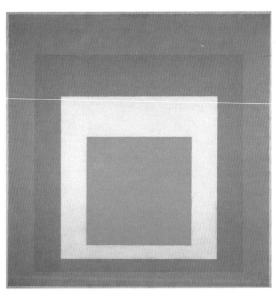

JOSEF ALBERS (1888–1976).
Homage to the Square: "Ascending," 1953.
Oil on composition board, 43½ x 43½ in. (110.5 x 110.5 cm).

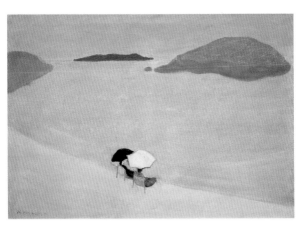

Milton Avery (1885–1965).
Sea Gazers, 1956.
Oil on canvas, 30 x 44 in. (76.2 x 111.8 cm).

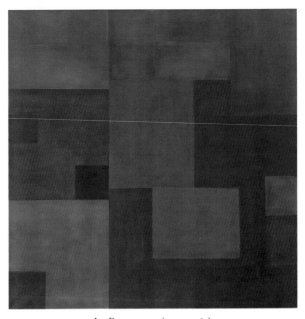

AD REINHARDT (1913–1967).
Number 17—1953, 1953.
Oil and tempera on canvas, 77¾ x 77¾ in. (197.5 x 197.5 cm).

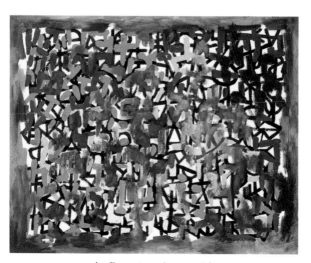

AD REINHARDT (1913–1967).
Untitled, n.d.
Gouache on cardboard, 16 x 20 in. (40.6 x 50.8 cm).

MYRON STOUT (1908–1987).
Untitled, No. 2, 1956.
Oil on canvas, 20 x 14 in. (50.8 x 35.6 cm).

LORSER FEITELSON (1898–1978).
Magical Space Forms, 1951.
Oil on canvas, 57¾ x 81¾ in. (146.7 x 207.6 cm).

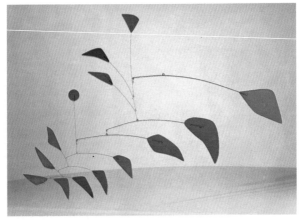

ALEXANDER CALDER (1898–1976).
Big Red, 1959.
Sheet metal and steel wire, 74 x 114 in. (188 x 289.6 cm).

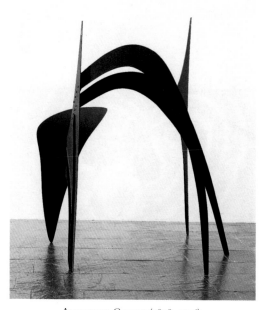

ALEXANDER CALDER (1898–1976).
The Arches, 1959.
Painted steel, 106 x 107½ x 87 in. (269.2 x 273.1 x 221 cm).

ALEXANDER CALDER (1898–1976).
Four Black Dots, 1974.
Gouache on paper, 29½ x 43 in. (74.9 x 109.2 cm).

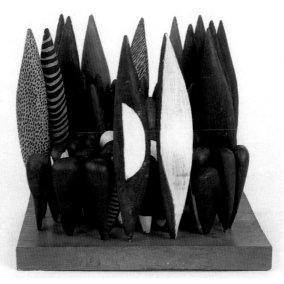

LOUISE BOURGEOIS (b. 1911).
One and Others, 1955.
Painted and stained wood, 18 x 20¹⁄₁₆ x 16¹⁵⁄₁₆ in.
(45.7 x 51 x 43 cm) overall.

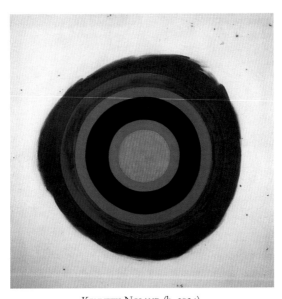

KENNETH NOLAND (b. 1924).
Song, 1958.
Synthetic polymer on canvas, 65 x 65 in. (165.1 x 165.1 cm).

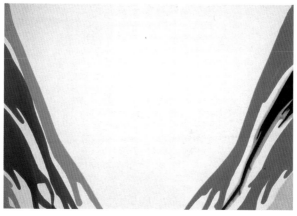

MORRIS LOUIS (1912–1962).
Gamma Delta, 1959–60.
Synthetic polymer on canvas, 102¾ x 152½ in. (261 x 387.4 cm).

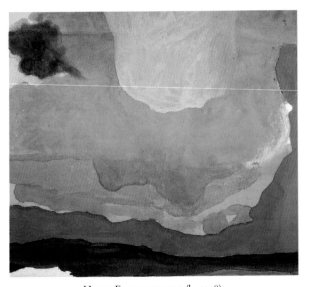

HELEN FRANKENTHALER (b. 1928).
Flood, 1967.
Synthetic polymer on canvas, 124 x 140 in. (315 x 355.6 cm).

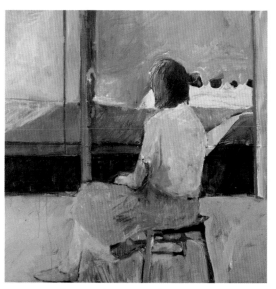

RICHARD DIEBENKORN (1922–1993).
Girl Looking at Landscape, 1957.
Oil on canvas, 59 x 60⅜ in. (149.9 x 153.4 cm).

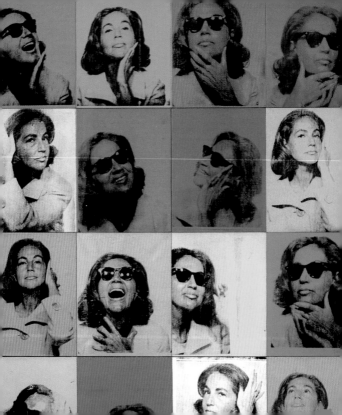

INTO THE SIXTIES

Through much of the 1950s, American art had been dominated by Abstract Expressionism and other types of biomorphic and hard-edged abstraction. However, by mid-decade, a variety of representational forms began to surface, culminating in what came to be known as Pop Art. The Whitney Museum's collection from this period has considerable range and depth and includes major works by virtually every key artist.

Robert Rauschenberg, in his early painting *Yoicks* (page 161), began to suggest real-world sources, such as a bed or quilt. Two years later he fully embraced the stuff and images of contemporary life in his assemblage *Satellite* (page 163). Other painters, such as Jasper Johns in his celebrated masterwork *Three Flags* (page 179), Andy Warhol in his iconic *Green Coca-Cola Bottles* (page 184), Robert Indiana in his daringly structured *The X-5* (page 191), and Roy Lichtenstein in his ironic *Little Big Painting* (page 177), made direct reference to the signs of everyday life: consumer culture, advertising, communications, and transportation. While subject in these works is prominent, the language of painting—style, structure, and format—is still of critical importance. Whether it is Johns' layered,

encaustic impasto, Warhol's silkscreen surface, Lichtenstein's reference to comic-book Benday dots, or Indiana's eccentrically shaped canvases, the syntax of the painting is as significant as the subject itself.

Sculptors of this period literally engaged the material of urban and industrial culture, eschewing traditional sculptural methods of casting and carving and traditional materials such as bronze and marble. In an effort to discover new forms of beauty, Richard Stankiewicz used industrial and domestic castoffs to construct his graceful *Kabuki Dancer* (page 162), while John Chamberlain welded automobile metal for his disturbing but sensuous *Velvet White* (page 172) and Mark di Suvero, in homage to Franz Kline's black-and-white paintings, constructed *Hankchampion* (page 170) from recycled wooden building beams.

Numerous artists returned to the figure itself as a way of conveying the growing sense of alienation in American culture. George Segal's sculpture *Walk, Don't Walk* (page 192), literally cast from life, addresses the anonymity and isolation of urban street life. Edward Kienholz's life-size tableau *The Wait* (page 166), complete with living parakeet, evokes the loneliness of old age. In typical, satirical fashion, Andy Warhol in his *Before and After, 3* (page 185) caricatures the need to conform to conventional definitions of beauty.

The techniques and style of photography had considerable impact on the work of many Pop artists and on Photo-Realists such as Robert Bechtle (page 189). However, the medium in its own right had numerous practitioners whose works are emblematic of the 1960s. Robert Frank's atmospheric, black-and-white photograph *New York Subway* (page 165) is a remarkable image shot from a dramatic perspective that also signals the importance of jazz music during this period. Louis Faurer's disturbing portrait *Viva* (page 187) captures an unglamorous aspect of one of Andy Warhol's Factory stars.

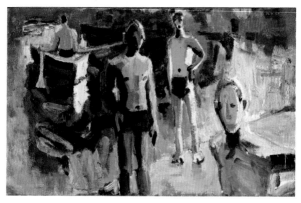

DAVID PARK (1911–1960).
Four Men, 1958.
Oil on canvas, 57 x 92 in. (144.8 x 233.7 cm).

Robert Rauschenberg (b. 1925).
Yoicks, 1953.
Oil, fabric, and paper on canvas, 96 x 72 in. (243.8 x 182.9 cm).

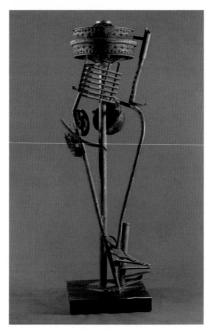

RICHARD STANKIEWICZ (1922–1983).
Kabuki Dancer, 1956.
Iron and steel, height, 84 in. (213.4 cm), with base.

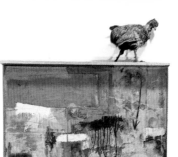

ROBERT RAUSCHENBERG (b. 1925).
Satellite, 1955.
Oil, fabric, paper, and wood on canvas with stuffed pheasant,
79⅜ x 43¼ x 5⅝ in. (201.6 x 109.9 x 14.3 cm).

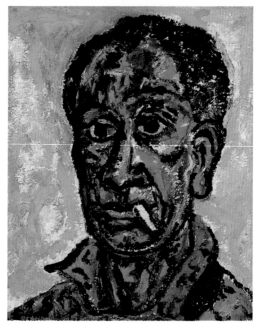

BEAUFORD DELANEY (1901–1979).
Auto-Portrait, 1965.
Oil on canvas, 24 x 20 in. (61 x 50.8 cm).

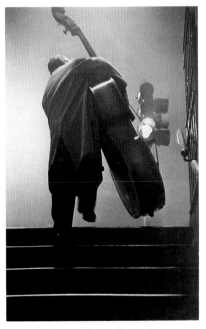

ROBERT FRANK (b. 1924).
New York Subway, 1953.
Gelatin silver print, 13½ x 8¹¹⁄₁₆ in.
(34.3 x 22.1 cm).

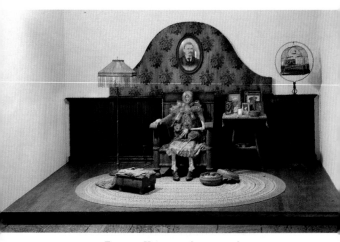

EDWARD KIENHOLZ (1927–1994).
The Wait, 1964–65.
Tableau: wood, fabric, polyester resin, flock, metal, bones, glass,
paper, leather, varnish, black-and-white photographs,
taxidermied cat, live parakeet, wicker, and plastic; 13 units,
80 x 160 x 84 in. (203.2 x 406.4 x 213.4 cm) overall.

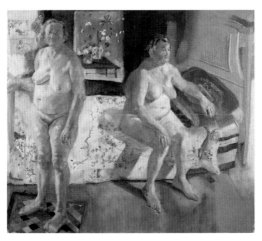

Larry Rivers (b. 1923).
Double Portrait of Berdie, 1955.
Oil on canvas, 70¾ x 82½ in. (179.7 x 209.6 cm).

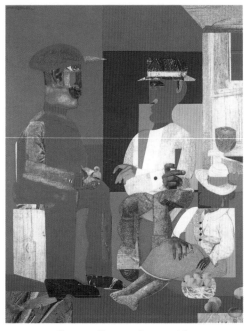

ROMARE BEARDEN (1912–1988).
Eastern Barn, 1968.
Paper collage on board, 55½ x 44 in. (141 x 111.8 cm).

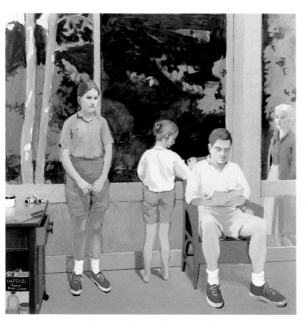

FAIRFIELD PORTER (1907–1975).
The Screen Porch, 1964.
Oil on canvas, 79½ x 79½ in. (201.9 x 201.9 cm).

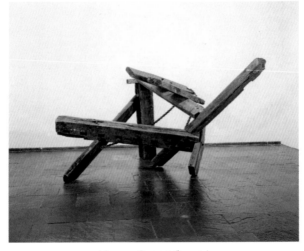

MARK DI SUVERO (b. 1933).
Hankchampion, 1960.
Wood and chains, 77½ x 149 x 105 in.
(196.9 x 378.5 x 266.7 cm) overall.

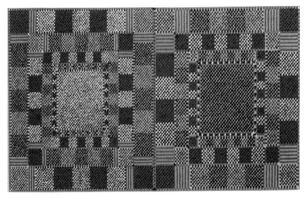

ALFRED J. JENSEN (1903–1981).
Timaeus III and IV, 1966.
Oil on canvas, diptych, 60 x 100 in. (152.4 x 254 cm).

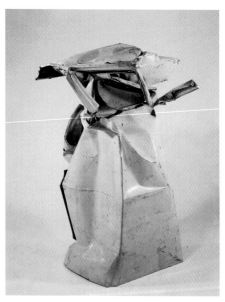

John Chamberlain (b. 1927).
Velvet White, 1962.
Painted and chromium-plated steel,
80¾ x 53 x 49³⁄₁₆ in. (205.1 x 134.6 x 124.9 cm) overall.

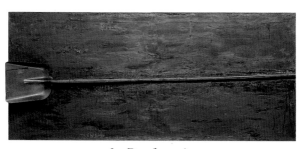

JIM DINE (b. 1935).
A Black Shovel, Number 2, 1962.
Oil and shovel on canvas, 36 x 84½ in. (91.4 x 214.6 cm).

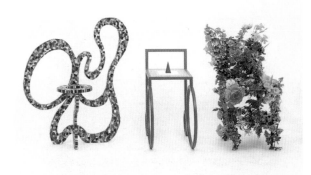

LUCAS SAMARAS (b. 1936).
Chair Transformations Numbers 12, 16, 25A, 1969–70.
Synthetic polymer on wood, 41½ x 36 x 13 in.
(105.4 x 91.4 x 33 cm); synthetic polymer on wood,
30 x 14¹³⁄₁₆ x 28¼ (76.2 x 37.6 x 71.8 cm); plastic and wire,
42 x 20 x 22 in. (106.7 x 50.8 x 55.9 cm).

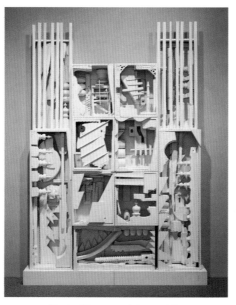

Louise Nevelson (1899–1988).
Dawn's Wedding Chapel II, 1959.
Painted wood, 115⅞ x 83½ x 10½ in.
(294.3 x 212.1 x 26.7 cm), with base.

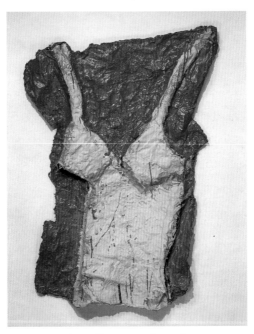

CLAES OLDENBURG (b. 1929).
Braselette, 1961.
Painted plaster, muslin, and wire, 41 x 30¼ x 4 in.
(104.1 x 76.8 x 10.2 cm) overall.

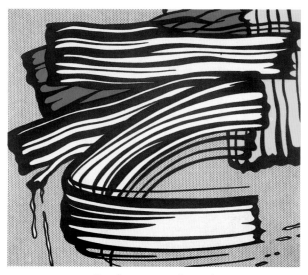

ROY LICHTENSTEIN (b. 1923).
Little Big Painting, 1965.
Oil and synthetic polymer on canvas, 68 x 80 in.
(172.7 x 203.2 cm).

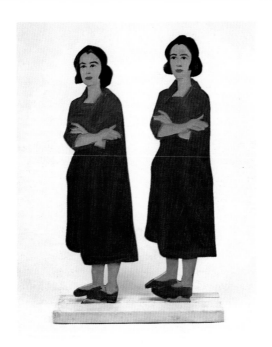

ALEX KATZ (b. 1927).
Ada Ada, 1959.
Oil on wood, 39 x 24⅛ x 6⅜ in. (99.1 x 61.3 x 16.2 cm).

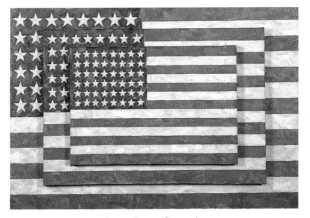

JASPER JOHNS (b. 1930).
Three Flags, 1958.
Encaustic on canvas, 30⅞ x 45½ x 5 in. (78.4 x 115.6 x 12.7 cm).

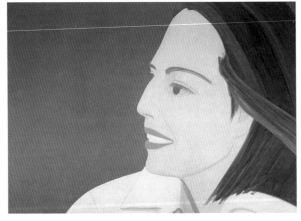

ALEX KATZ (b. 1927).
The Red Smile, 1963.
Oil on canvas, 78¾ x 114¾ in. (200 x 291.5 cm).

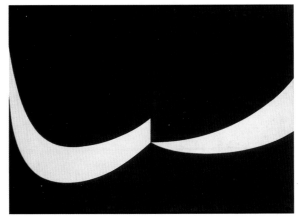

ELLSWORTH KELLY (b. 1923).
Atlantic, 1956.
Oil on canvas, 2 panels, 80 x 114 in. (203.2 x 289.6 cm) overall.

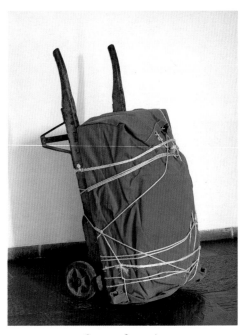

CHRISTO (b. 1935).
Package on Hand Truck, 1973.
Metal, canvas, wood, and rope,
51 15/16 x 24¼ x 29 in. (131.9 x 61.6 x 73.7 cm).

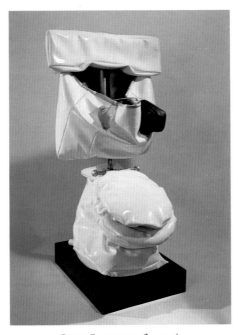

CLAES OLDENBURG (b. 1929).
Soft Toilet, 1966.
Vinyl, plexiglass, and kapok on painted wood base,
57 1/16 x 27 5/8 x 28 1/16 in. (144.9 x 70.2 x 71.3 cm) overall.

183

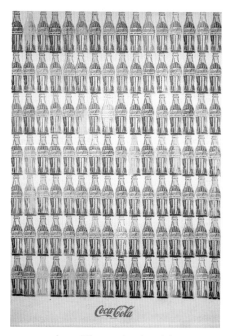

ANDY WARHOL (1928–1987).
Green Coca-Cola Bottles, 1962.
Oil on canvas, 82½ x 57 in. (209.6 x 144.8 cm).

ANDY WARHOL (1928–1987).
Before and After, 3, 1962.
Synthetic polymer and graphite on canvas,
72 x 99⅝ in. (182.9 x 253 cm).

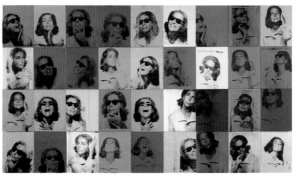

ANDY WARHOL (1928–1987).
Ethel Scull 36 Times, 1963.
Synthetic polymer paint silkscreened on canvas,
79¾ x 143¼ in. (202.6 x 363.9 cm) overall.

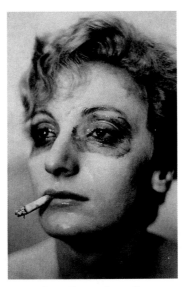

LOUIS FAURER (b. 1916).
Viva, 1962.
Gelatin silver print, 13¹³⁄₁₆ x 9¼ in. (35.1 x 23.5 cm).

DIANE ARBUS (1923–1971).
A family on their lawn one Sunday in Westchester, N.Y., 1968
(printed c. 1969–70). Gelatin silver print,
19¹³⁄₁₆ x 16 in. (50.3 x 40.6 cm).

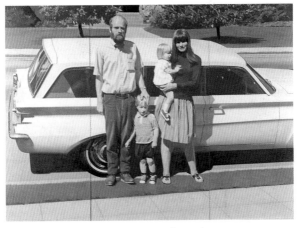

ROBERT BECHTLE (b. 1932).
'61 Pontiac, 1968–69.
Oil on canvas, 59¾ x 84¼ in. (151.8 x 214 cm).

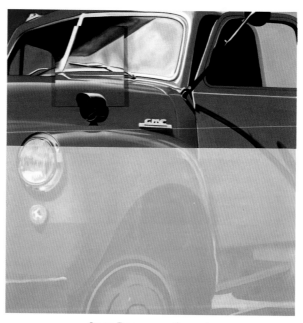

James Rosenquist (b. 1933).
Untitled (Broome Street Truck), 1963.
Oil on canvas, 72 x 72 in. (182.9 x 182.9 cm).

ROBERT INDIANA (b. 1928).
The X-5, 1963.
Oil on canvas, 108 x 108 in. (274.3 x 274.3 cm) overall.

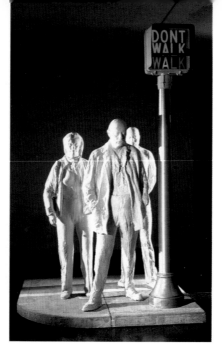

GEORGE SEGAL (b. 1924).
Walk, Don't Walk, 1976.
Plaster, cement, metal, painted wood, and electric light,
104 x 72 x 72 in. (264.2 x 182.9 x 182.9 cm).

EDWARD RUSCHA (b. 1937).
Large Trademark with Eight Spotlights, 1962.
Oil on canvas, 66¾ x 133¼ in. (169.5 x 338.5 cm).

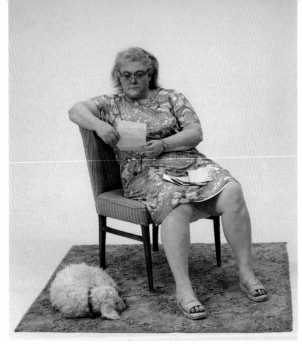

DUANE HANSON (1925–1996).
Woman with Dog, 1977.
Cast polyvinyl, polychromed in acrylic with
cloth and hair, life-size.

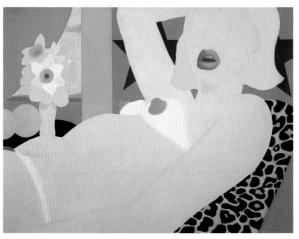

Tom Wesselmann (b. 1931).
Great American Nude, #57, 1964.
Synthetic polymer on composition board,
48 x 65 in. (121.9 x 165.1 cm).

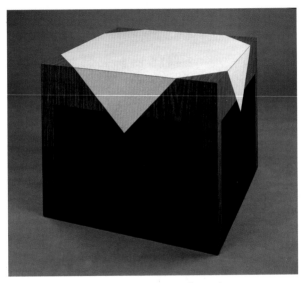

RICHARD ARTSCHWAGER (b. 1923).
Description of Table, 1964.
Formica on wood, 26⅛ x 31⅞ x 31⅞ in. (66.4 x 81 x 81 cm).

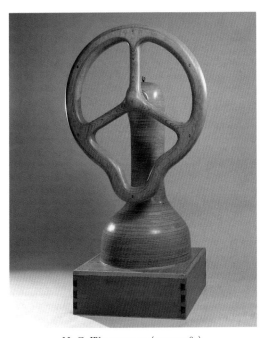

H. C. WESTERMANN (1922–1981).
Antimobile, 1966.
Laminated plywood, 67¼ x 35½ x 27½ in.
(170.8 x 90.2 x 69.9 cm) overall.

MINIMALISM, POST-MINIMALISM, AND CONCEPTUAL ART

In 1959 Frank Stella produced a series of black "pinstripe" paintings that anticipated the Minimalist art of the early 1960s. The Whitney's great *Die Fahne Hoch* (page 202), one in the series, is a completely self-referential work that makes no allusions to any subject outside itself—despite its German title, which translates as "the banner raised." As Stella said, "What you see is what you see." A few years later, the sculptors Carl Andre, Robert Morris, Tony Smith, Robert Smithson, and Donald Judd, among others, began to exhibit work that consisted of pared-down, purified, primary forms often structured by a grid. They wanted to create a radical type of sculpture that had no hierarchical elements, made no anthropomorphic or representational suggestions, and gave no sense of the individual artist's hand. Their work, which came to be called Minimalism, was an art of perception, an art that shaped space and the viewer's visceral experience of an object in a particular space.

Most of the artists involved in this pursuit disliked the term Minimalism. Although their work was elemental and structured in simple units, the objects themselves had considerable variety in color, form, texture, scale, and material. Tony Smith's huge steel *Die* (page 205) impresses us with its solitary mass, its somber sense of gravity. In contrast, Dan Flavin's *Untitled* (page 204) uses standard fluorescent tubes that dematerialize everything touched by its glow. Carl Andre's *Twenty-Ninth Copper Cardinal* (page 209), a piece that can be walked on, forces us to reconsider the traditional definition of sculpture as a discrete object that rests on a base and is simply meant to be viewed.

Other artists of the early 1960s, including Sol LeWitt, Joseph Kosuth, and Lawrence Weiner, maintained that the idea was the essential character of an art work. These artists typically conceived of a repeatable work rather than a unique, precious object. In many cases, the pieces were remade for each exhibition space according to instructions provided by the artist, a process that leads to variability, as in Lawrence Weiner's *Here There & Everywhere* (page 208), which redefines each space in which it is installed. Sol LeWitt's mesmerizing wall work *A six inch (15cm) grid . . .* (page 213, background) radically expands our concept of drawing as merely a preparatory medium in the evolution of a painting or sculpture. LeWitt's concept covers all four

walls of the space in which it is installed, making it an environment as much as a drawing.

As a reaction against Minimalism, a number of artists began to return to expressivity, process, and the feeling of the handmade. Their art referred to the elemental forms of Minimalism yet reintroduced representational imagery, as in Joel Shapiro's *Untitled* (page 221). Other artists embraced natural materials and organic forms: Eva Hesse in her *Untitled (Rope Piece)* (page 219) suggests the collapse of the Minimalist grid through weblike, visceral elements, and Bruce Nauman, in *Six Inches of My Knee Extended to Six Feet* (page 214), literally exaggerates a part of the body.

Still other artists subtly subverted the crisp, linear geometry and the manufactured look of Minimalism: Richard Serra's *Prop* (page 222) consists of a beam, made from a sheet of rolled lead, which leans against a painterly looking square of the same material; Richard Tuttle's *Drift III* (page 220) reinterprets the massive, masculine structures of Minimalist art through a pair of diminutive, imperfectly formed arch shapes painted in non-industrial, pastel colors.

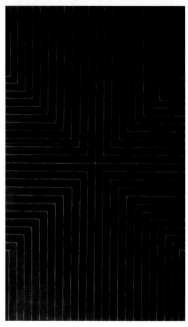

FRANK STELLA (b. 1936).
Die Fahne Hoch, 1959.
Enamel on canvas, 121½ x 73 in. (308.6 x 185.4 cm).

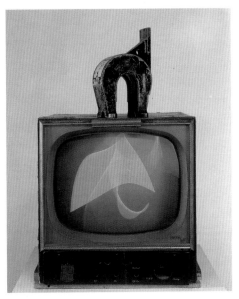

NAM JUNE PAIK (b. 1932).
Magnet TV, 1965.
Black-and-white television set with magnet,
28⅜ x 19¼ x 24½ in. (72.1 x 48.9 x 62.2 cm) overall.

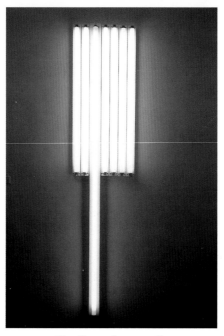

DAN FLAVIN (1933–1996).
Untitled, 1966.
Fluorescent lights, 96 x 21 x 3½ in. (243.8 x 53.3 x 8.9 cm).

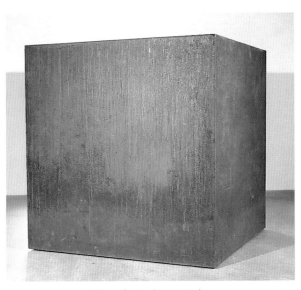

TONY SMITH (1912–1980).
Die, 1962.
Steel, 72⅜ x 72⅜ x 72⅜ in. (183.8 x 183.8 x 183.8 cm).

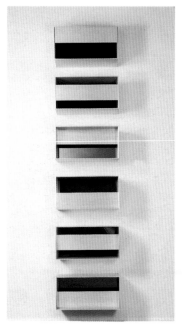

DONALD JUDD (1928–1994).
Untitled, 1984.
Aluminum and plexiglass, 177³⁄₁₆ x 39³⁄₈ x 19¹¹⁄₁₆ in.
(450.1 x 100 x 50 cm) overall.

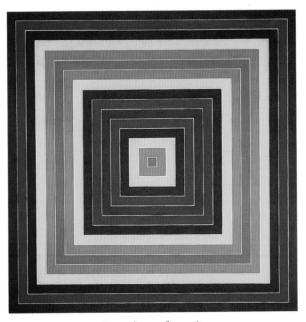

Frank Stella (b. 1936).
Gran Cairo, 1962.
Synthetic polymer on canvas, 85½ x 85½ in. (217.2 x 217.2 cm).

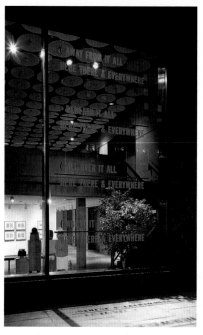

LAWRENCE WEINER (b. 1942).
Here There & Everywhere, 1989.
Wall installation, dimensions variable.

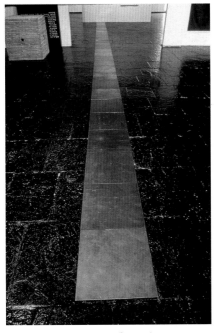

Carl Andre (b. 1935).
Twenty-Ninth Copper Cardinal, 1975.
Copper, 29 units, ³⁄₁₆ x 20 x 20 in. (.5 x 50.8 x 50.8 cm) overall.

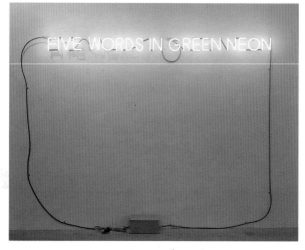

JOSEPH KOSUTH (b. 1945).
Five Words in Green Neon, 1965.
Neon tubing, 62⅛ x 80⅝ x 6 in. (157.8 x 204.8 x 15.2 cm) overall.

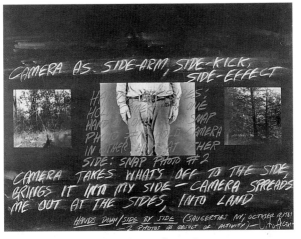

VITO ACCONCI (b. 1940).
Hands Down/Side by Side, 1969.
Gelatin silver prints and chalk on paperboard,
29⅞ x 39¹⁵⁄₁₆ in. (75.9 x 101.4 cm).

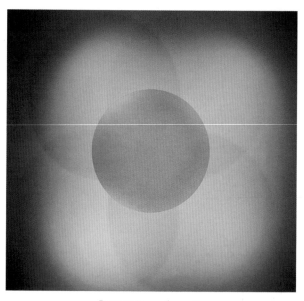

ROBERT IRWIN (b. 1928).
No Title, 1966–67.
Acrylic on aluminum, diameter, 48 in. (121.9 cm).

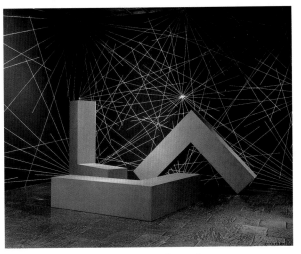

ROBERT MORRIS (b. 1931).
Untitled (L-beams), 1965. Stainless steel,
96 x 96 x 24 in. (243.8 x 243.8 x 61 cm).
Background: SOL LeWITT (b. 1928). *A six inch (15 cm) grid . . . ,*
1976. Crayon lines and graphite grid on walls, dimensions variable.

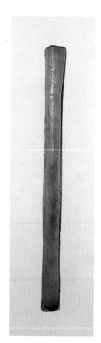

BRUCE NAUMAN (b. 1941).
Six Inches of My Knee Extended to Six Feet, 1967.
Fiberglass, 68½ x 5¾ x 3⅞ in. (174 x 14.6 x 9.8 cm).

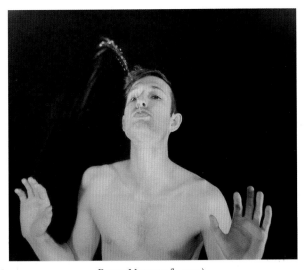

BRUCE NAUMAN (b. 1941).
Self-Portrait as a Fountain, 1966, from the series *Photograph Suite*.
Chromogenic color photograph, 20¹⁄₁₆ x 23¹⁵⁄₁₆ in. (51 x 60.8 cm).

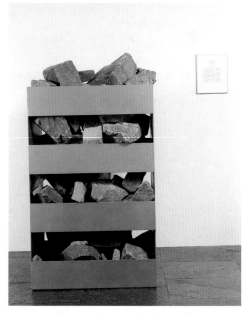

ROBERT SMITHSON (1938–1973).
Non-site (Palisades—Edgewater, N.J.), 1968, plus map
and description. Painted aluminum, enamel, and stone,
56 x 26 x 36 in. (142.2 x 66 x 91.4 cm); ink on paper, 1½ x 2 in.
(3.8 x 5.1 cm) and 7⅜ x 9¾ in. (18.7 x 24.8 cm).

DAN GRAHAM (b. 1942).
New Highway Restaurant, Jersey City, 1967;
2 House Home, Staten Island, New York, 1978, 1967–78.
Chromogenic color photographs mounted on paperboard,
34⅝ x 25¹⁄₁₆ in. (87.9 x 63.7 cm) overall.

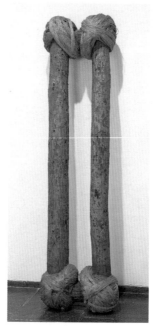

JACKIE WINSOR (b. 1941).
Bound Logs, 1972–73.
Wood and hemp, 114 x 29 x 18 in. (289.6 x 73.7 x 45.7 cm).

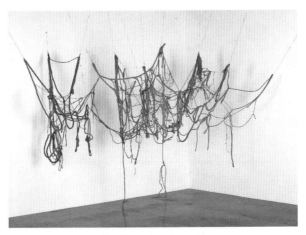

Eva Hesse (1936–1970).
Untitled (Rope Piece), 1969–70.
Latex over rope, string, and wire, 2 strands, dimensions variable.

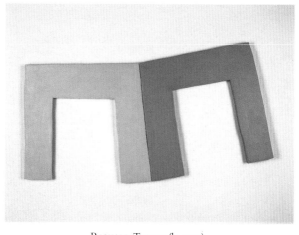

RICHARD TUTTLE (b. 1941).
Drift III, 1965.
Painted wood, 2 panels, 24¼ x 52¾ x 1¼ in.
(61.6 x 134 x 3.2 cm) overall.

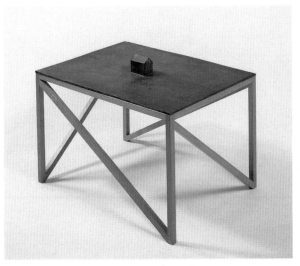

JOEL SHAPIRO (b. 1941).
Untitled, 1975-76.
Bronze on wood base, 20⅞ x 28⅞ x 21⁹⁄₁₆ in.
(53 x 73.3 x 54.8 cm) overall.

221

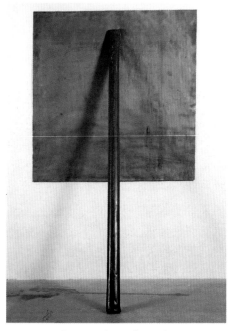

RICHARD SERRA (b. 1939).
Prop, 1968.
Lead antimony, 97½ x 60 x 43 in. (247.7 x 152.4 x 109.2 cm).

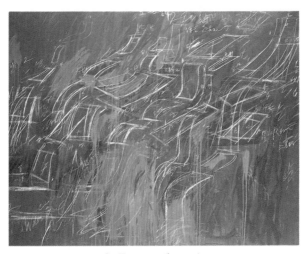

CY TWOMBLY (b. 1928).
Untitled, 1969.
Oil and crayon on canvas, 78 x 103 in. (198.1 x 261.6 cm).

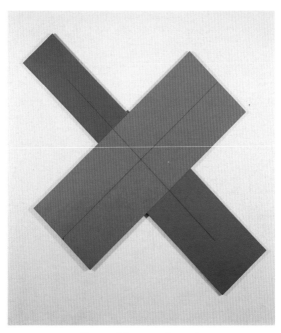

ROBERT MANGOLD (b. 1937).
Three Red X Within X, 1981.
Acrylic and graphite on canvas, 3 panels,
109⅞ x 109 in. (279.1 x 276.9 cm) overall.

AGNES MARTIN (b. 1912).
Milk River, 1963.
Oil on canvas, 72 x 72 in. (182.9 x 182.9 cm).

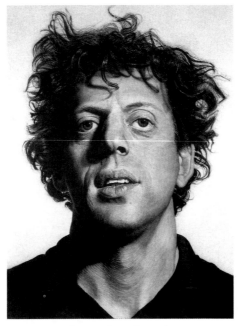

CHUCK CLOSE (b. 1940).
Phil, 1969.
Synthetic polymer on canvas, 108 x 84 in. (274.3 x 213.4 cm).

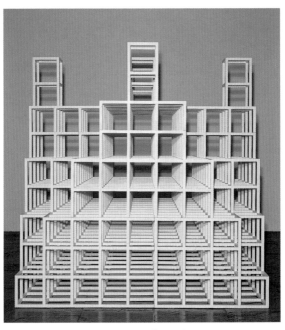

Sol LeWitt (b. 1928).
Five Towers, 1986.
Painted wood, 8 units, 86⁹⁄₁₆ x 86⁹⁄₁₆ x 86⁹⁄₁₆ in.
(219.9 x 219.9 x 219.9 cm) overall.

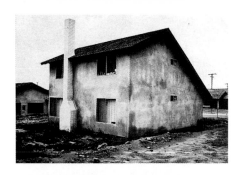

Lewis Baltz (b. 1945).
Element no. 15 (top) and element no. 2 (bottom) from
The Tract Houses, 1971. Gelatin silver prints, 10¹³⁄₁₆ x 10¹³⁄₁₆ in.
(27.5 x 27.5 cm) [no. 15]; 10¹⁵⁄₁₆ x 10¹⁵⁄₁₆ in. (27.8 x 27.8 cm) [no. 2].

BRICE MARDEN (b. 1938).
Summer Table, 1972.
Oil and wax on canvas, 3 panels,
60 x 105 in. (152.4 x 266.7 cm) overall.

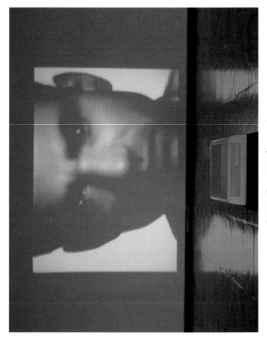

PETER CAMPUS (b. 1937).
Head of a Man with Death on His Mind, 1978.
Video projection, dimensions variable.

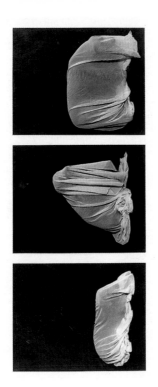

WILLIAM WEGMAN (b. 1943).
Man Ray Under Sheet, 1976.
3 gelatin silver prints, 22⅛ x 40⅛ in. (56.2 x 101.9 cm) overall.

231

THE SEVENTIES AND BEYOND

The profusion of art made during the last quarter of the twentieth century has been largely defined by the catchall term *postmodern,* since it leaves behind those modern concerns that define art as primarily about its own making, materials, and meaning. Although it is impossible to consider recent art from any single vantage, many artists during the past two decades have shown renewed interest in the social and political function of art itself.

Works as diverse as John Baldessari's *Ashputtle* (page 242), David Salle's *Sextant in Dogtown* (page 255), Jenny Holzer's *Unex Sign #1* (page 256), and Jeff Koons' *New Hoover Convertibles . . .* (page 258) in various ways address the notion of the artwork as commodity—as bound up in the world of commerce and shaped by the advertising, mass media, and entertainment industries. Baldessari's grid of film stills, for example, comments on the myths perpetuated by Hollywood, while Salle's painting renders a rather sinister vision of voyeurism and sexuality using images reminiscent of pulp magazines. Holzer's electronic advertising sign offers up messages on love, life, and violence. And Koons' display case of vacuum cleaners speaks of the allure of consumer pleasure. Unlike Pop Art, these

works must be viewed not merely as a commentary on but as a product and critique of our marketing culture.

Other artists deal with social issues more directly. Their concerns range from sexual identity, as in Cindy Sherman's *Untitled Film Still #35* (page 257), Laurie Simmons' *Walking Camera II* (page 259), and Mike Kelley's *More Love Hours . . .* (page 261), to racial and ethnic issues, as in David Hammons' *Untitled* (page 271), Alison Saar's *Skin/Deep* (page 263), and Pepón Osorio's *Angel: The Shoe Shiner* (page 264).

These recent works present an extraordinary range of materials, from used toys, an afghan, and candles in the Kelley piece to the hair that is the primary component of Hammons' sculpture. Art materials, however, are selected on a case-by-case basis to develop a particular idea. Form remains significant, but it is secondary to meaning.

There are also innumerable artists whose highly personal imagery continues to derive from the formalist concerns of modern art. Whether for an artist of the older generation, such as Jasper Johns or Louise Bourgeois, or a midcareer artist such as Terry Winters, Susan Rothenberg, Elizabeth Murray, or Carroll Dunham, art is an investigation that takes into account both modern and postmodern impulses, steering clear of a defined connection to a singular direction or aesthetic. Although we live in a media-dominated culture, these artists assert the relevance of painting and sculpture.

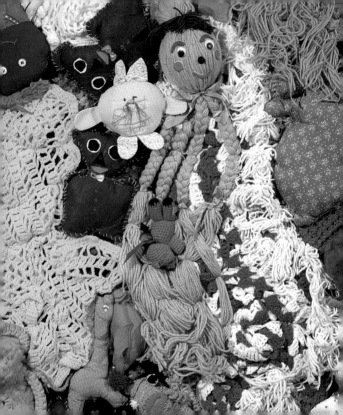

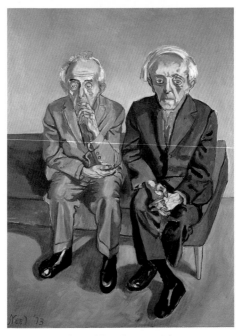

ALICE NEEL (1900–1984).
The Soyer Brothers, 1973.
Oil on canvas, 60 x 46 in. (152.4 x 116.8 cm).

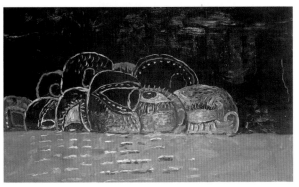

PHILIP GUSTON (1913–1980).
Cabal, 1977.
Oil on canvas, 68 x 116 in. (172.7 x 294.6 cm).

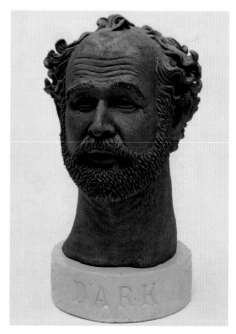

ROBERT ARNESON (1930–1992).
Whistling in the Dark, 1976.
Terracotta and glazed ceramic, 34³⁄₁₆ x 21 x 19⅛ in.
(86.8 x 53.3 x 48.6 cm) overall.

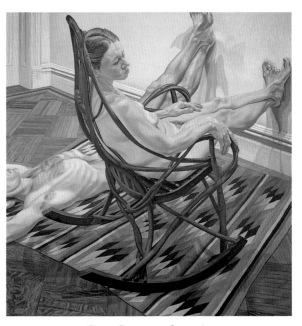

PHILIP PEARLSTEIN (b. 1924).
Female Model on Adirondacks Rocker, Male Model on Floor, 1980.
Oil on canvas, 72 x 72 in. (182.9 x 182.9 cm).

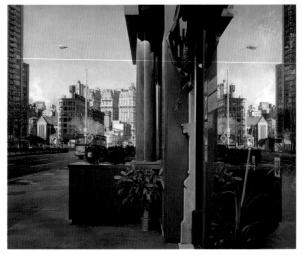

RICHARD ESTES (b. 1932).
Ansonia, 1977.
Oil on canvas, 48 x 60 in. (121.9 x 152.4 cm).

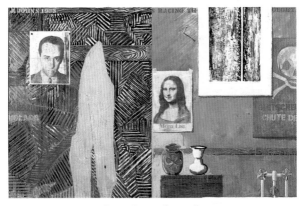

JASPER JOHNS (b. 1930).
Racing Thoughts, 1983.
Encaustic and collage on canvas, 48 x 75⅛ in. (121.9 x 190.8 cm).

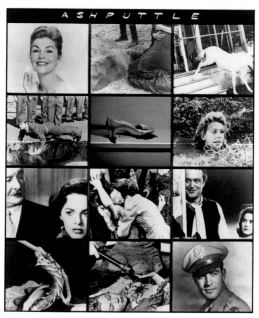

John Baldessari (b. 1931).
Ashputtle, 1982.
11 black-and-white photographs, 1 color photograph,
and text panel, 84 x 72 in. (213.4 x 182.9 cm) overall.

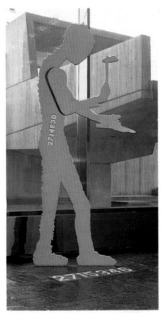

Jonathan Borofsky (b. 1942).
Hammering Man at 2715346, 1981.
Painted wood and masonite with metal stripping and motor:
139½ x 66¾ in. (354.3 x 169.5 cm);
12½ x 56¼ x ⅛ in. (31.8 x 142.9 x .3 cm).

ELIZABETH MURRAY (b. 1940).
Children Meeting, 1978.
Oil on canvas, 101 x 127 in. (256.5 x 322.6 cm).

ALICE AYCOCK (b. 1946).
Untitled (Shanty), 1978.
Wood, 54 x 30 x 30 in. (137.2 x 76.2 x 76.2 cm) overall.

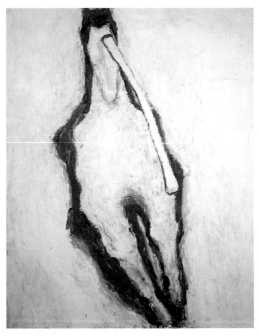

SUSAN ROTHENBERG (b. 1945).
For the Light, 1978–79.
Acrylic and flashe on canvas, 105 x 87 in. (266.7 x 221 cm).

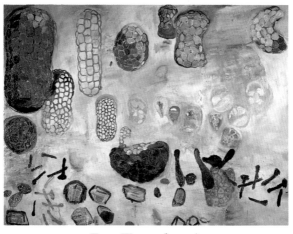

TERRY WINTERS (b. 1949).
Good Government, 1984.
Oil on linen, 101¼ x 137¼ in. (257.2 x 348.6 cm).

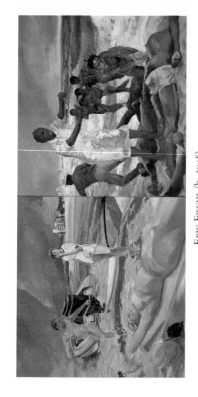

Eric Fischl (b. 1948).
A Visit To/A Visit From/The Island, 1983.
Oil on canvas, 2 panels, 84 x 168 in. (213.4 x 426.7 cm) overall.

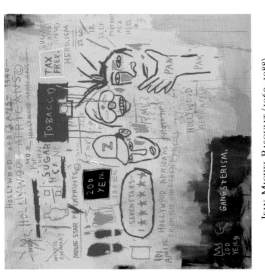

JEAN-MICHEL BASQUIAT (1960–1988).
Hollywood Africans, 1983.
Acrylic and mixed media on canvas, 84 x 84 in. (213.4 x 213.4 cm).

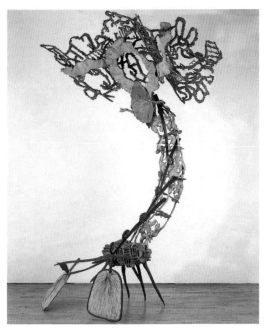

NANCY GRAVES (1940–1995).
Cantileve, 1983.
Bronze with polychrome patina, 98 x 68 x 54 in.
(248.9 x 172.7 x 137.2 cm).

CARROLL DUNHAM (b. 1949).
Pine Gap, 1985-86.
Mixed media on wood veneers, 77 x 41 in. (195.6 x 104.1 cm).

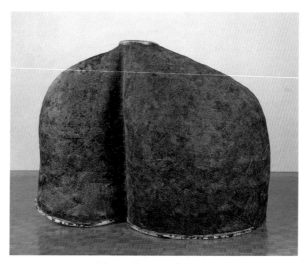

MARTIN PURYEAR (b. 1941).
Sanctum, 1985.
Wood, wire mesh, and tar, 76 x 109 x 87 in. (193 x 276.9 x 221 cm).

PAT STEIR (b. 1938).
July Waterfall, 1991.
Oil on canvas, 102¼ x 116⅛ in. (259.7 x 295 cm).

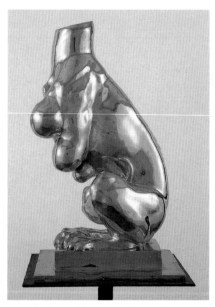

LOUISE BOURGEOIS (b. 1911).
Nature Study, 1984.
Bronze, 30 x 14½ x 19 in. (76.2 x 36.8 x 48.3 cm).

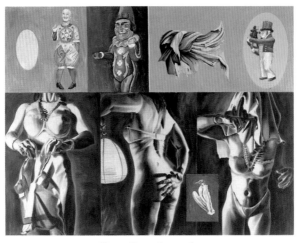

DAVID SALLE (b. 1952).
Sextant in Dogtown, 1987.
Oil and acrylic on canvas, 96³⁄₁₆ x 126¼ in. (244.3 x 320.7 cm).

JENNY HOLZER (b. 1950).
Unex Sign #1, 1983.
Spectrocolor machine with moving graphics,
30½ x 116½ x 11⅝ in. (77.5 x 295.9 x 29.5 cm).

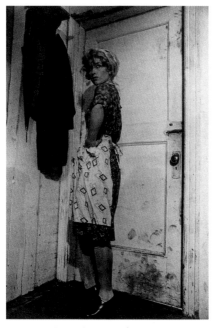

CINDY SHERMAN (b. 1954).
Untitled Film Still #35, 1979.
Gelatin silver print, 9⁷⁄₁₆ x 6⅜ in. (24 x 16.2 cm).

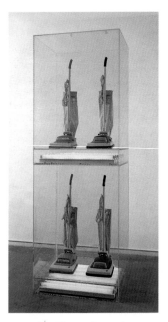

Jeff Koons (b. 1955).
New Hoover Convertibles, Green, Blue; New Hoover Convertibles, Green, Blue; Double-decker, 1981–87.
Vacuum cleaners, plexiglass, and fluorescent lights, 22 units, 116 x 41 x 28 in. (294.6 x 104.1 x 71.1 cm) overall.

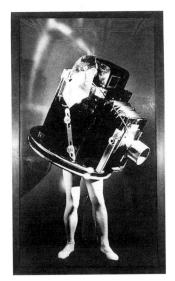

LAURIE SIMMONS (b. 1949).
Walking Camera II (Jimmy the Camera), 1987.
Gelatin silver print, 82¹³⁄₁₆ x 47½ in. (210.3 x 120.7 cm).

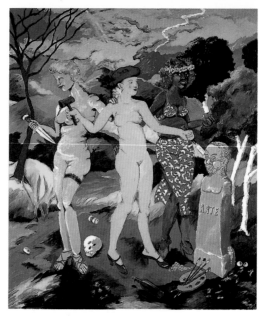

ROBERT COLESCOTT (b. 1925).
The Three Graces: Art, Sex and Death, 1981.
Synthetic polymer on canvas, 84 x 71⅞ in. (213.4 x 182.6 cm).

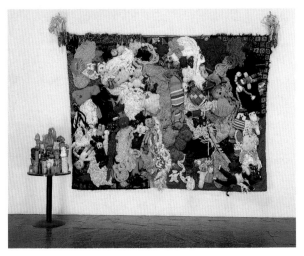

MIKE KELLEY (b. 1954).
More Love Hours Than Can Ever Be Repaid and The Wages of Sin,
1987. Stuffed fabric toys and afghans on canvas with dried corn;
wax candles on wood and metal base, 90 x 119¼ x 5 in.
(228.6 x 302.9 x 12.7 cm) plus candles and base.

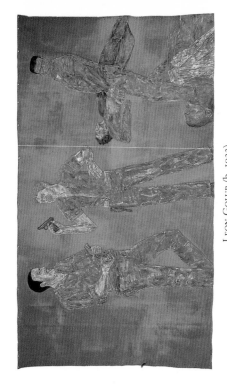

LEON GOLUB (b. 1922).
White Squad I, 1982.
Synthetic polymer on canvas, 120 x 184 in. (304.8 x 467.4 cm).

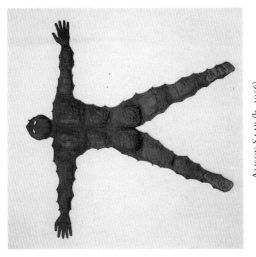

ALISON SAAR (b. 1956).
Skin/Deep, 1993.
Ceiling tin, nails, and copper, 82 x 84 x 2½ in.
(208.3 x 213.4 x 6.4 cm) installed.

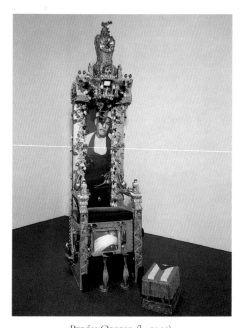

PEPÓN OSORIO (b. 1955).
Angel: The Shoe Shiner, 1993.
Painted wood, rubber, fabric, glass, ceramic, shells, painted cast iron, 2 video monitors, 2 color videotapes, hand-tinted photographs, paper, and mirror, overall dimensions variable.

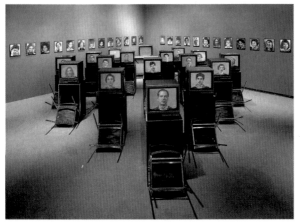

ADRIAN PIPER (b. 1948).
Out of the Corner, 1990.
64 gelatin silver prints and 17 videotapes: gelatin silver prints,
14⅝ x 11⅝ in. (37.1 x 29.5 cm) each; videotapes,
1½ x 6¾ x 10 in. (3.8 x 17.1 x 25.4 cm) each.

SHERRIE LEVINE (b. 1947).
Untitled (Golden Knots: 1), 1987.
Oil on plywood under plexiglass, 62⅝ x 50⁹⁄₁₆ x 3½ in.
(159.1 x 128.4 x 8.9 cm) overall.

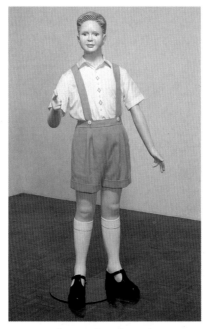

CHARLES RAY (b. 1953).
Boy, 1992.
Painted fiberglass, steel, and fabric, 71½ x 27 x 34 in.
(181.6 x 68.6 x 86.4 cm) overall.

PHILIP TAAFFE (b. 1955).
Passionale per Circulum Anni, 1993-94.
Mixed media on canvas, 137¼ x 116 in. (348.6 x 294.6 cm).

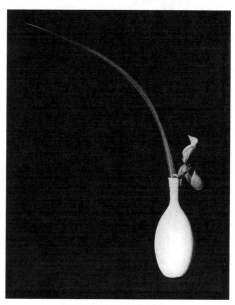

Robert Mapplethorpe (1946–1989).
Orchid and Leaf in White Vase, 1982.
Gelatin silver print, 35¹³⁄₁₆ x 29½ in. (91 x 74.9 cm)

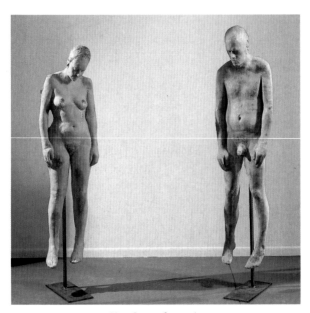

KIKI SMITH (b. 1954).
Untitled, 1990.
Beeswax and microcrystalline wax figures on metal stand:
female figure, 73½ in. (186.7 cm) height; male figure,
76 ¹⁵⁄₁₆ in. (195.4 cm) height.

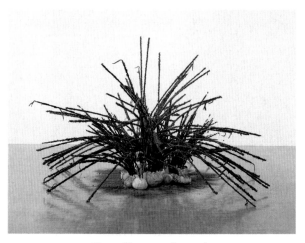

DAVID HAMMONS (b. 1943).
Untitled, 1992.
Copper, wire, hair, stone, fabric, and thread,
60 in. (152.4 cm) height.

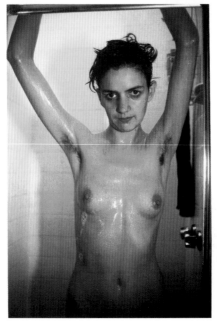

NAN GOLDIN (b. 1953).
Siobhan in the Shower, 1991.
Cibachrome print, 48 x 36 in. (121.9 x 91.4 cm).

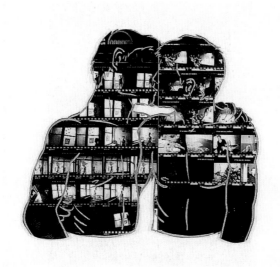

David Wojnarowicz (1954–1992).
Untitled, 1988.
Synthetic polymer on color contact sheets,
11 x 12⅝ in. (27.9 x 32.1 cm).

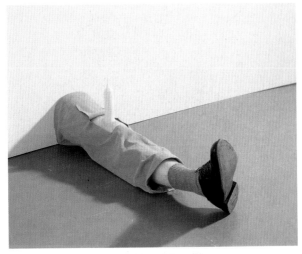

Robert Gober (b. 1954).
Untitled, 1991.
Wax, cloth, wood, leather, and human hair,
13½ x 7 x 37½ in. (34.3 x 17.8 x 95.3 cm).

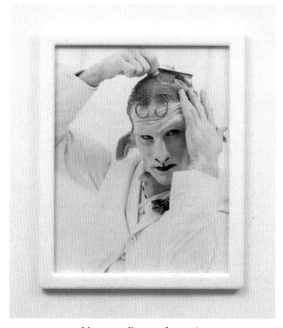

MATTHEW BARNEY (b. 1967).
CR 4: Valve, 1994.
1 of 4 chromogenic prints, each with self-lubricating plastic frame,
31½ x 25½ in. (80 x 64.8 cm).

DONORS' CREDITS

(Listed by page number)

57: Purchase, with funds from the Mrs. Percy Uris Purchase Fund (86.49a–b)

58: Gift of the artist (69.255)

59: Purchase, with funds from a public fund-raising campaign in May 1982. One half the funds were contributed by the Robert Wood Johnson Charitable Trust. Additional major donations were given by The Lauder Foundation; the Robert Lehman Foundation, Inc.; the Howard and Jean Lipman Foundation, Inc.; an anonymous donor; the T. M. Evans Foundation, Inc.; MacAndrews & Forbes Group, Inc.; the DeWitt Wallace Fund, Inc.; Martin and Agneta Gruss; Anne Phillips; Mr. and Mrs. Laurance S. Rockefeller; the Simon Foundation, Inc.; Marylou Whitney; Bankers Trust Company; Mr. and Mrs. Kenneth N. Dayton; Joel and Anne Ehrenkranz; Irvin and Kenneth Feld; Flora Whitney Miller. More than 500 individuals from 26 states and abroad also contributed to the campaign (83.36.1–56)

60: Purchase (53.38)

61: Gift of Mr. and Mrs. Harry L. Koenigsberg (67.66)

62: Purchase, with funds from Evelyn and Leonard A. Lauder, Thomas H. Lee, and the Modern Painting and Sculpture Committee (95.188)

63: Promised gift of Charles H. Carpenter, Jr. (P.11.94)

64: Purchase, with funds from Gertrude Vanderbilt Whitney (31.172)

65: Purchase (32.43)

66: 50th Anniversary Gift of Mr. and Mrs. B.H. Friedman in honor of Gertrude Vanderbilt Whitney, Flora Whitney Miller, and Flora Miller Biddle (84.37)

67: Purchase, with funds from Mrs. William A. Marsteller (78.17)

68: Gift of Gertrude Vanderbilt Whitney (31.177)

69: Purchase (77.9)

70: Purchase, with funds from the Friends of the Whitney Museum of American Art (63.22)

71: Purchase (41.3)

72: Gift of Gertrude Vanderbilt Whitney (31.169)

73: Purchase (42.15)

78: Purchase, with funds from the Friends of the Whitney Museum of American Art (60.54)

79: Purchase and exchange (50.8)

80: Josephine N. Hopper Bequest (70.1170)

81: Purchase, with funds from Gertrude Vanderbilt Whitney (31.426)

82: 50th Anniversary Gift of Mr. and Mrs. Albert Hackett in honor of Edith and Lloyd Goodrich (84.31)

83: Josephine N. Hopper Bequest (70.343)

84: Josephine N. Hopper Bequest (70.1094)

85: Purchase (31.690)

86: Purchase (31.100)

87: Purchase (33.10)

88: Purchase (33.79)

89: Purchase (33.80)

90: Purchase (31.408)

91: Gift of Mr. and Mrs. Benno C. Schmidt in memory of Mr. Josiah Marvel, first owner of this picture (77.91)

92: Purchase, with funds from the Print Committee (95.53)

93: Purchase (37.43)

94: Purchase (31.293)

95: Katherine Schmidt Shubert Bequest (82.43.1)

96: Purchase (32.25)

97: Mrs. Percy Uris Bequest (85.49.2)

98: Purchase, with funds from The Hearst

Corporation and The Norman and Rosita Winston Foundation, Inc. (82.20)

99: Purchase (43.14)

100: Gift of Mr. and Mrs. Roy R. Neuberger (51.11)

101: Gift of Julien Levy for Maro and Natasha Gorky in memory of their father (50.17)

102: Gift of Edith and Milton Lowenthal in memory of Juliana Force (49.22)

103: Purchase, with funds from the Juliana Force Purchase Award (50.23)

104: Gift of Malcolm S. Forbes (64.42)

105: Purchase (39.12)

106: Gift of Lilyan S. and Toby Miller (94.167)

107: Purchase (41.42)

108: Gift of the Theodore Roszak Estate (83.33.5)

109: Purchase, with funds from the Burroughs Wellcome Purchase Fund and the National Endowment for the Arts (79.6)

110: 50th Anniversary Gift of Mr. and Mrs. Edwin A. Bergman (80.54)

111: Purchase (50.3)

112: Kay Sage Tanguy Bequest (64.51)

113: Purchase, with funds from the Simon Foundation, Inc. (72.129)

118: Purchase (52.2)

119: Purchase, with funds from the Friends of the Whitney Museum of American Art (59.38)

120: Purchase, with funds from Emily Fisher Landau (85.44)

121: Purchase (52.3)

122: Purchase, with funds from the Julia B. Engel Purchase Fund and the Drawing Committee (85.19a)

123: Purchase, with funds from the Julia B. Engel Purchase Fund and the Drawing Committee (85.18)

124: Gift of The Mark Rothko Foundation, Inc. (85.43.1)

125: Promised 50th Anniversary Gift of the artist (P.4.79)

126: Purchase (53.12)

127: Purchase, with funds from Frances and Sydney Lewis (by exchange), the Mrs. Percy Uris Purchase Fund, and the Painting and Sculpture Committee (87.7)

128: Purchase (56.12)

129: Gift of Mr. and Mrs. Samuel M. Kootz (57.3)

130: Purchase (55.35)

131: Purchase, with funds from the Friends of the Whitney Museum of American Art (60.63)

132: Purchase, with funds from the Friends of the Whitney Museum of American Art (57.10)

133: Purchase, with funds from the Friends of the Whitney Museum of American Art, Mr. and Mrs. Eugene M. Schwartz, Samuel A. Seaver, and Charles Simon (68.9)

134: Purchase, with funds from Agnes Gund and an anonymous donor (79.43)

135: Purchase (54.14)

136: Purchase, with funds from the Friends of the Whitney Museum of American Art (62.15)

137: Purchase, with funds from the Friends of the Whitney Museum of American Art (67.18)

138: Purchase (56.44)

139: Purchase, with funds from the Friends of the Whitney Museum of American Art (69.31)

140: Purchase, with funds from the Friends of the Whitney Museum of American Art (61.34)

141: Purchase (50.24)

142: Purchase (54.34)

143: Lawrence H. Bloedel Bequest (77.1.3)

144: Purchase (55.36)

145: 50th Anniversary Gift of an anonymous donor (79.58)

146: Promised gift of Charles H. Carpenter, Jr. (P.27.94)

147: Gift of the Los Angeles Art Association Galleries (80.53)

148: Purchase, with funds from the Friends of the Whitney Museum of American Art, and exchange (61.46)

149: Gift of Howard and Jean Lipman (82.44)

150: Purchase, with funds from the Howard and Jean Lipman Foundation, Inc. (74.94)

151: Purchase (56.43)

152: Purchase, with funds from the Friends of the Whitney Museum of American Art (63.31)

153: Purchase, with funds from the Glen Alden Foundation and the McCrory Foundation, Inc. (69.57)

154: Purchase, with funds from the Friends of the Whitney Museum of American Art (68.12)

155: Gift of Mr. and Mrs. Alan H. Temple (61.49)

160: Purchase, with funds from an anonymous donor (59.27)

161: Gift of the artist (71.210)

162: Purchase, with funds from the Friends of the Whitney Museum of American Art (57.12)

163: Gift of Claire B. Zeisler and purchase with funds from the Mrs. Percy Uris Purchase Fund (91.85)

164: Purchase, with funds from the Wilfred P. and Rose J. Cohen Purchase Fund, the Richard and Dorothy Rodgers Fund, the Katherine Schmidt Shubert Purchase Fund, and the Mrs. Percy Uris Purchase Fund (95.2)

165: Purchase, with funds from the Photography Committee in memory of Eugene M. Schwartz (95.169)

166: Gift of the Howard and Jean Lipman Foundation, Inc. (66.49a–m)

167: Gift of an anonymous donor (56.9)

168: Purchase (69.14)

169: Lawrence H. Bloedel Bequest (77.1.41)

170: Gift of Mr. and Mrs. Robert C. Scull (73.85)

171: Purchase, with funds from the Friends of the Whitney Museum of American Art (67.29)

172: Gift of the Albert A. List Family (70.1579a–b)

173: Gift of Dr. and Mrs. Bernard Brodsky (67.63)

174: Purchase, with funds from the Howard and Jean Lipman Foundation, Inc. (70.1573, 1574, 1575)

175: Purchase, with funds from the Howard and Jean Lipman Foundation, Inc. (70.68)

176: Gift of Howard and Jean Lipman (91.34.5)

177: Purchase, with funds from the Friends of the Whitney Museum of American Art (66.2)

178: Gift of the artist (88.39)

179: 50th Anniversary Gift of the Gilman Foundation, Inc., The Lauder Foundation, A. Alfred Taubman, an anonymous donor, and purchase (80.32)

180: Purchase, with funds from the Painting and Sculpture Committee (83.3)

181: Purchase (57.9)

182: Gift of Mr. and Mrs. Albrecht Saalfield (74.74)

183: 50th Anniversary Gift of Mr. and Mrs. Victor W. Ganz (79.82a–b)

184: Purchase, with funds from the Friends of the Whitney Museum of American Art (68.25)

185: Purchase, with funds from Charles Simon (71.226)

186: Gift of Ethel Redner Scull (86.61a–jj)

187: Purchase, with funds from the Photography Committee (95.5)

188: Purchase, with funds from the Mr. and Mrs. Arthur G. Altschul Purchase Fund, Michele Gerber Klein, and the Photography Committee (95.3)

189: Purchase, with funds from the Richard and Dorothy Rodgers Fund (70.16)

190: Purchase (64.20)

191: Purchase (64.9)

192: Purchase, with funds from the Louis and Bessie Adler Foundation, Inc., Seymour M. Klein, President; the Gilman Foundation, Inc.; the Howard and Jean Lipman Foundation, Inc.; and the National Endowment for the Arts (79.4)

193: Purchase, with funds from the Mrs. Percy Uris Purchase Fund (85.41)

194: Purchase, with funds from Frances and Sydney Lewis (78.6)

195: Purchase, with funds from the Friends of the Whitney Museum of American Art (65.10)

196: Gift of the Howard and Jean Lipman Foundation, Inc. (66.48)

197: Purchase, with funds from the Howard and Jean Lipman Foundation, Inc., and exchange (69.4a–b)

202: Gift of Mr. and Mrs. Eugene M. Schwartz and purchase, with funds from the John I.H. Baur Purchase Fund; the Charles and Anita Blatt Fund; Peter M. Brant; B.H. Friedman; the Gilman Foundation, Inc.; Susan Morse Hilles; The Lauder Foundation; Frances and Sydney Lewis; the Albert A. List Fund; Philip Morris Incorporated; Sandra Payson; Mr. and Mrs. Albrecht Saalfield;

Mrs. Percy Uris; Warner Communications, Inc.; and the National Endowment for the Arts (75.22)

203: Purchase, with funds from Dieter Rosenkranz (86.60a–b)

204: Gift of Howard and Jean Lipman (71.214)

205: Purchase, with funds from the Louis and Bessie Adler Foundation, Inc.; James Block; The Sondra and Charles Gilman, Jr., Foundation, Inc.; Penny and Mike Winton; and the Painting and Sculpture Committee (89.6)

206: Purchase, with funds from the Brown Foundation, Inc., in memory of Margaret Root Brown (85.14a–f)

207: Purchase, with funds from the Friends of the Whitney Museum of American Art (63.34)

208: Purchase, with funds from the Contemporary Painting and Sculpture Committee (94.136)

209: Purchase, with funds from the Gilman Foundation, Inc., and the National Endowment for the Arts (75.55)

210: Purchase, with funds from Leonard A. Lauder (93.42a–c)

211: Purchase, with funds from the Photography Committee (92.12)

212: Purchase, with funds from the Howard and Jean Lipman Foundation, Inc. (68.42)

213: Gift of Howard and Jean Lipman (76.29)

213 (background): Purchase with funds from the Gilman Foundation, Inc. (78.1.1–4)

214: Partial and promised gift of Robert A. M. Stern (P.14.91)

215: Purchase (70.50.9)

216: Purchase, with funds from the Howard and Jean Lipman Foundation, Inc. (69.6a–b)

217: Purchase, with funds from the Photography Committee (93.2a–b)

218: Purchase, with funds from the Howard and Jean Lipman Foundation, Inc. (74.53)

219: Purchase, with funds from Eli and Edythe L. Broad, the Mrs. Percy Uris Purchase Fund, and the Painting and Sculpture Committee (88.17a–b)

220: Purchase, with funds from Mr. and Mrs. William A. Marsteller and the Painting and Sculpture Committee (83.18a–b)

221: Purchase, with funds from Mrs. Oscar Kolin (76.22a–b)

222: Purchase, with funds from the Howard and Jean Lipman Foundation, Inc. (69.20a–b)

223: Purchase, with funds from Mr. and Mrs. Rudolph B. Schulhof (69.29)

224: Purchase, with funds from the Painting and Sculpture Committee (83.4a–c)

225: Purchase, with funds from the Larry Aldrich Foundation Fund (64.10)

226: Purchase, with funds from Mrs. Robert M. Benjamin (69.102)

227: Purchase, with funds from the Louis and Bessie Adler Foundation, Inc., Seymour M. Klein, President; the John I.H. Baur Purchase Fund; the Grace Belt Endowed Purchase Fund; The Sondra and Charles Gilman, Jr., Foundation, Inc.; The List Purchase Fund; and the Painting and Sculpture Committee (88.7a–h)

228: Purchase, with funds from the Wilfred P. and Rose J. Cohen Purchase Fund, the John I.H. Baur Purchase Fund, the Grace Belt Endowed Purchase Fund, and the Photography Committee (top: 93.70.15; bottom: 93.70.2)

229: Purchase, with funds from the National Endowment for the Arts (73.30)

230: Promised gift of The Bohen Foundation (P.4.91)

231: Gift of Holly and Horace Solomon (79.7a–c)

236: Purchase, with funds from Arthur M. Bullowa, Sydney Duffy, Stewart R. Mott, and Edward Rosenthal (74.77)

237: 50th Anniversary Gift of Mr. and Mrs. Raymond J. Learsy (81.38)

238: Purchase, with funds from Frances and Sydney Lewis (77.37a–b)

239: Purchase, with funds from the Painting and Sculpture Committee, and the Friends of the Whitney Museum of American Art, by exchange (80.39)

240: Purchase, with funds from Frances and Sydney Lewis (77.33)

241: Purchase, with funds from the Burroughs Wellcome purchase Fund; Leo Castelli; the Wilfred P. and Rose J. Cohen Purchase Fund; the Julia B. Engel Purchase Fund; the Equitable Life Assurance Society of the United States Purchase Fund; The Sondra and Charles Gilman, Jr., Foundation, Inc.; S. Sidney Kahn; The Lauder Foundation, Leonard and Evelyn Lauder Fund; the Sara Roby Foundation; and the Painting and Sculpture Committee (84.6)

242: Purchase, with funds from the Painting and Sculpture Committee (83.8a–m)

243: Gift of Robert and Jane Meyerhoff (90.30a–b)

244: Purchase, with funds from the Louis and Bessie Adler Foundation, Inc., Seymour M. Klein, President (78.34)

245: Gift of Raymond J. Learsy (84.71.1)

246: Purchase, with funds from Peggy and Richard Danziger (79.23)

247: Purchase, with funds from The Mnuchin Foundation and the Painting and Sculpture Committee (85.15)

248: Purchase, with funds from the Louis and

Bessie Adler Foundation, Inc., Seymour M. Klein, President (83.17a–b)

249: Gift of Douglas S. Cramer (84.23)

250: Purchase, with funds from the Painting and Sculpture Committee (83.39)

251: Purchase, with funds from The Mnuchin Foundation (86.36)

252: Purchase, with funds from the Painting and Sculpture Committee (85.72)

253: Promised gift of Robert Miller and Betsy Wittenborn Miller (P.3.92)

254: Purchase, with funds from the Painting and Sculpture Committee (84.42)

255: Purchase, with funds from the Painting and Sculpture Committee (88.8)

256: Purchase, with funds from the Louis and Bessie Adler Foundation, Inc., Seymour M. Klein, President (84.8a–c)

257: Gift of Barbara and Eugene Schwartz (88.50.4)

258: Purchase, with funds from The Sondra and Charles Gilman, Jr., Foundation, Inc., and the Painting and Sculpture Committee (89.30a–v)

259: Purchase, with funds from the Photography Committee (94.107)

260: Gift of Raymond J. Learsy (91.59.1)

261: Purchase, with funds from the Painting and Sculpture Committee (89.13a–e)

262: Gift of The Eli Broad Family Foundation and purchase, with funds from the Painting and Sculpture Committee (94.67)

263: Purchase, with funds from the Painting and Sculpture Committee (93.34a–b)

264: Purchase, with funds from the Painting and Sculpture Committee (93.100a–s)

265: Gift of the Peter Norton Family Foundation (94.38a–ffff)

266: Purchase, with funds from the Painting and Sculpture Committee (88.48a–b)

267: Purchase, with funds from Jeffrey Deitch, Bernardo Nadal-Ginard, and Penny and Mike Winton (92.131a–i)

268: Purchase, with funds from the Painting and Sculpture Committee and the Ruth and Seymour M. Klein Foundation, with additional funding from Sandra and Gerald Fineberg and Linda and Harry Macklowe (94.68)

269: Gift of Anne and Joel Ehrenkranz in honor of Leonard A. Lauder (95.209)

270: Purchase, with funds from the Painting and Sculpture Committee (91.13a–u)

271: Purchase, with funds from the Mrs. Percy Uris Bequest and the Painting and Sculpture Committee (92.128a–u)

272: Gift of the artist and Pace/MacGill Gallery (92.133)

273: Purchase, with funds from the Photography Committee (95.88)

274: Purchase, with funds from Robert W. Wilson (92.6)

275: Promised gift of Eileen and Peter Norton (P.2a–d.95)

INDEX

PHOTOGRAPH CREDITS

Accettola, Peter: 215; Allison, David: 265; Clements, Geoffrey: cover, back cover, frontispiece, 19, 20, 22, 23, 24, 26, 31, 32, 33, 34, 42, 43, 47, 48, 50, 60, 62, 63, 65, 68, 69, 70, 71, 72, 73, 74, 83, 85, 87, 90, 91, 92, 93, 94, 95, 96, 97, 99, 100, 101, 102, 103, 104, 106, 107, 109, 110, 111, 113, 114, 121, 122, 123, 124, 125, 126, 128, 129, 135, 137, 141, 142, 143, 145, 146, 147, 150, 152, 154, 155, 156, 161, 164, 165, 167, 168, 169, 173, 176, 178, 180, 184, 186, 187, 188,

189, 190, 195, 204, 205, 209, 210, 211, 212, 216, 217, 219, 220, 222, 224, 226, 227, 228, 229, 230, 231, 235, 236, 240, 241, 243, 244, 245, 246, 247, 250, 251, 252, 255, 257, 260, 266, 268, 269, 271, 272, 275; Collins, Sheldan C.: 14, 18, 21, 25, 29, 36, 40, 45, 64, 105, 119, 208, 223, 242; Dupuy, Pierre: 264; Gamma One Conversions: 202, 225; Gardner, Rick: 127; Jacobson, Bill: 49, 80, 178, 213, 232, 249; Robert E. Mates Studio: 27, 30, 61, 82, 86, 120, 160, 177, 203, 207; O'Brien,

Michael James: 275; Phillips, Beth: 253; Sandak/Macmillan Publishing Company: 67, 88, 89, 98, 148, 162, 171, 182, 185, 191, 237, 261, 263; Simms, Roger John: 239; Sloman, Steven: 52, 53, 78, 81, 84, 112, 130, 131, 132, 133, 138, 139, 181, 193, 196, 248; Thompson, Jerry L.: spine, 8, 28, 35, 54, 56, 58, 66, 118, 136, 149, 151, 166, 170, 172, 174, 175, 183, 192, 194, 206, 218, 221, 238, 254, 267, 270, 274; Tropea, Michael: 163; Varon, Malcom: 51, 197; Victor's Photography: 140

First edition

10 9 8 7 6 5 4 3 2 1

Library of Congress Cataloging-in-Publication Data

Whitney Museum of American Art.
American art of the twentieth century : treasures of the Whitney Museum of American Art / foreword by David A. Ross ; introduction by Adam D. Weinberg ; chapter introductions by Adam D. Weinberg and Beth Venn.
 p. cm.
"A tiny folio."
Includes index.
ISBN 0-7892-0263-8
1. Art, American—Catalogs.
2. Art, Modern—20th century—
United States—Catalogs. 3. Art—Catalogs. 4. Whitney Museum of American Art—Catalogs. I. Title.
N6512.W532 1998
709'.73'074741—dc21
97-3257

TINY FOLIOS™ AVAILABLE FROM ABBEVILLE PRESS

- AMERICAN IMPRESSIONISM 1-55859-801-4 • $11.95

- ANGELS 0-7892-0025-2 • $11.95

- THE GREAT BOOK OF FRENCH IMPRESSIONISM 1-55859-336-5 • $11.95

- JAPANESE PRINTS: THE ART INSTITUTE OF CHICAGO
 1-55859-803-0 • $11.95

- NORMAN ROCKWELL: 332 MAGAZINE COVERS 1-55859-224-5 • $11.95

- TREASURES OF BRITISH ART: TATE GALLERY 1-55859-772-7 • $11.95

- TREASURES OF FOLK ART 1-55859-560-0 • $11.95

- TREASURES OF IMPRESSIONISM AND POST-IMPRESSIONISM:
 NATIONAL GALLERY OF ART 1-55859-561-9 • $11.95

- TREASURES OF THE LOUVRE 1-55859-477-9 • $11.95

- TREASURES OF THE MUSÉE D'ORSAY 1-55859-783-2 • $11.95

- TREASURES OF THE MUSÉE PICASSO 1-55859-836-7 • $11.95

- TREASURES OF THE NATIONAL MUSEUM OF THE AMERICAN INDIAN
 0-7892-0105-4 • $11.95

- TREASURES OF 19TH- AND 20TH-CENTURY PAINTING:
 THE ART INSTITUTE OF CHICAGO 1-55859-603-8 • $11.95

- TREASURES OF THE PRADO 1-55859-558-9 • $11.95

- TREASURES OF THE UFFIZI 1-55859-559-7 • $11.95

- WOMEN ARTISTS: THE NATIONAL MUSEUM OF WOMEN IN THE ARTS
 1-55859-890-1 • $11.95